PETERBOROUGH
THROUGH TIME
A Second Selection
June *&* Vernon Bull

AMBERLEY PUBLISHING

Acknowledgements

In bringing together the content for the Second Selection we sought to ensure that the textual content is factually correct to the best of our knowledge and that it draws the reader into a city steeped in history in a gripping and appealing way. We felt it had to be written with local experience, in the correct context for both the geographical area and the subjects about which we write.

The authors are indebted to the following people without whose help this book would not have been possible.

The late Messrs. Harry Miles and John Jack Gaunt
Jean Miles
John & Josephine Gillatt
Stanley Hoare
John & Vera Seeley
Harry & Gwen Hurst
George & Trudie Meadows
Barbara Blackwell
Sarah Flight and Alan Sutton

First published 2011

Amberley Publishing
Cirencester Road, Chalford,
Stroud, Gloucestershire, GL6 8PE

www.amberley-books.com

Copyright © June & Vernon Bull, 2011

The right of June & Vernon Bull to be identified
as the Authors of this work has been asserted
in accordance with the Copyrights, Designs and
Patents Act 1988.

ISBN 978 1 84868 990 9

British Library Cataloguing in Publication Data.
A catalogue record for this book is available from
the British Library.

Typeset in 9.5pt on 12pt Celeste.
Typesetting by Amberley Publishing.
Printed in the UK.

Introduction

A Pageant of Progress

Many people have suggested that we produce a further book of Peterborough's past and present following the success of our publication in 2009.

So in this volume we have endeavoured to take you on a journey back in time of the city, which once bore the name of Medeshamstead until about 992 when it was changed to Burgh; the place having been walled in by Abbot Kenulf (992–1005). Thus Burgh in conjunction with St Peter became Peterborough or the Burgh of St Peter. Later because of the great wealth of the Abbey, the additional euphonious title of Gildenborough or Goldenborough was bestowed upon it.

It is remarkable that in size Peterborough Cathedral ranks among the first six in England. The painted wooden ceiling of the nave is considered to be a unique feature.

What is interesting about the area on which the city grew is that Stone Age man was here, so too were the Celts and the Romans, who wrought iron, raised roads and drained the Fens.

In more contemporary times Peterborough became a new town, with its own Development Corporation in the late 1970s/early 1980s and today its Public Realm development is being taken forward by Opportunity Peterborough.

Another interesting fact is that Peterborough took corporate status in 1874 – precisely a hundred years before local government reorganisation took hold. Equally odd is the coincidence that today Peterborough is one of the few Unitary Authorities.

The city is currently designated by the Government as part of the London-Stansted-Cambridge growth corridor. It is also destined to be one of four environment capitals – leading the way in recycling and eco-friendly energy.

Today's success has its roots in yesterday's developments and events, so this volume aims to tell some of the history of the City's past with insight and affection but also with some fascinating illustrations from the past and present.

Bibliography

Austin, G. D. *Peterborough Trams* Greater Peterborough Arts Council, 1978

Bull, June & Vernon *A Portrait in Old Picture Postcards,* 1988

Bull, June & Vernon and McKenzie Rita *Peterborough – Then and Now: A Portrait in Photographs and Old Postcards,* 1992

Bull, June & Vernon, Perry, S. and Sturgess, R. Peterborough – *A Third Portrait in Old Picture Postcards,* 1990

Dare, M. Paul *Northamptonshire Past and Present,* 1924

Dixon, George *Old Scarlett,* 1997

Gunton, Symon *The Cathedral Church of Peterborough,* 1686

Kelly's Directory – Peterborough, 1838, 1848, 1870, 1877, 1898, 1922, 1927, 1940, 1952, and 1965

Liquorice, Mary (ed) *Posh Folk,* Cambridgeshire Libraries Publications, 1991

Northampton Sites and Monuments Record

Perry, Stephen *Peterborough – A Second Portrait in Old Picture Postcards,* 1989

Peterborough Advertiser *Century Story 1854–1954*

Pevsner, N. *The Buildings of England – Northamptonshire,* 1961

Sweeting, Revd W. D. *Historical and architectural notes on the parish churches in and around Peterborough,* 1868

Victoria County History IV

Webb, Leslie *Some Peterborough Buildings*

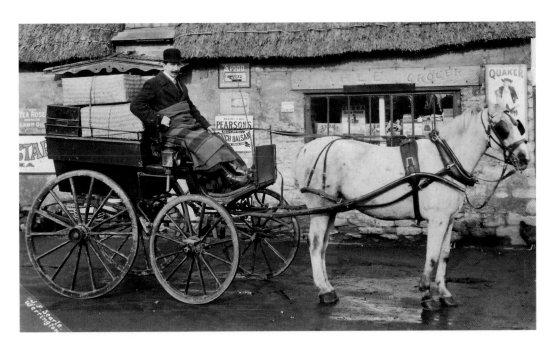

Searle's Grocer's Shop, 1 The Green, Werrington c. 1909
Local photographer J. F. Searle takes a picture of a family member outside the shop on Werrington Green. It is believed that the horse and trap in the picture belonged to John Searle who also owned a carrier business. Today the shop is long gone and has been replaced by a modern hairdresser's shop with a small house attached to the left. One could almost say that the horse and trap has been replaced by the car on the left.

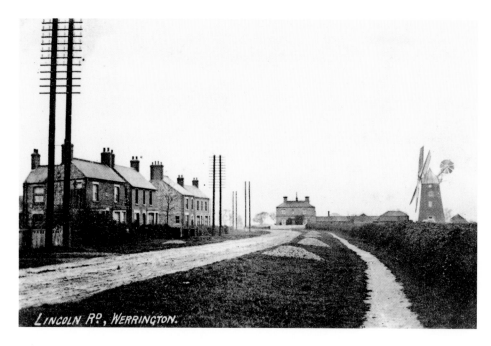

LINCOLN RD, WERRINGTON.

Lincoln Road, Werrington c. 1908/09

This postcard was postally used in 1909 and as the telegraph poles went up between 1908/09 (eventually being taken down in 1954) – we know that this scene must be close to the card's postally used date. On the right is the windmill that was damaged in the great storms of 1912. Its sails were removed in 1920 due to their deteriorating condition and the mill remained in use until 1952. At this time Ernest Goff was the miller and baker and locally it was referred to as "Goff's Mill". This postcard is of Mr Ernest Herbert Goff standing with his horse and cart in front of the mill in c. 1924. Mr Goff moved from Greenwich to Werrington in about 1902 and owned the mill until 1953.

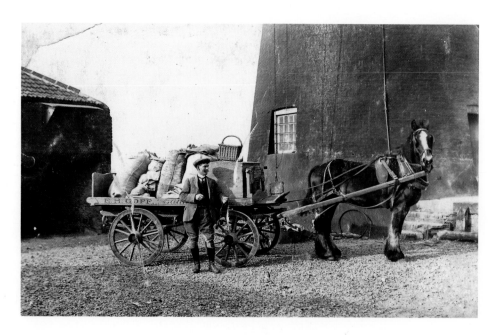

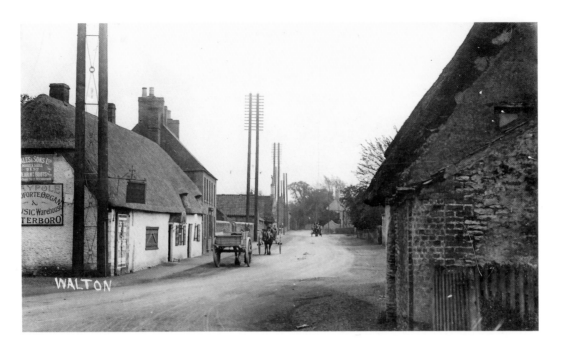

Lincoln Road, Walton, 1909

This postally used postcard of 1909 shows the Railway Inn, 310 Lincoln Road, Walton, originally known as the Plough Inn in 1900. In 1861 John Belton had a new shop built next door to the pub. That shop in 1891 became the first Post Office in Walton. It could only accept letters for posting and the selling of stamps. The site today is still occupied by a pub, namely The Royal Oak. Lincoln Road is now a busy dual carriageway with the roundabout in the distance being the junction to Mountsteven Avenue.

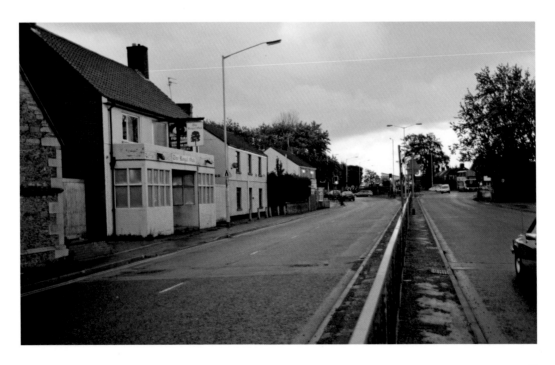

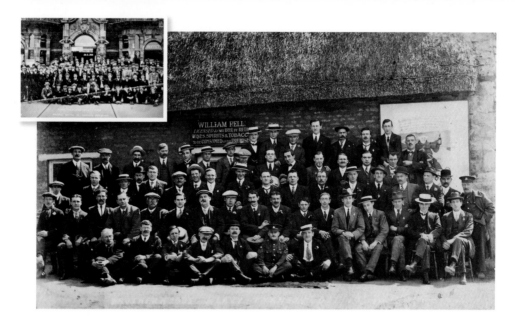

Brotherhood's Heavy Engineers Outing, *c.* **1919**

Here are some of Brotherhood's workers posing outside the George and Dragon in Castor, a year after the First World War, with some of the men still in uniform; presumably still enlisted. These men would be working on oil engines, air and gas compressors, refrigerating machinery and oil driven plant for electric generating purposes – including large turbines for electric light stations. Inset shows another annual outing of Brotherhood's workers but this time they are at Great Yarmouth on 2 July 1909. Here the men, all fitters, are photographed outside the railway station at Great Yarmouth. The proprietor of the George and Dragon located at Castor Hill in 1919 was William Pell. During the First World War the George & Dragon ran as a convalescent home for wounded soldiers with the help of William's wife, Fanny. The pub is now a private residence called "Dragon House".

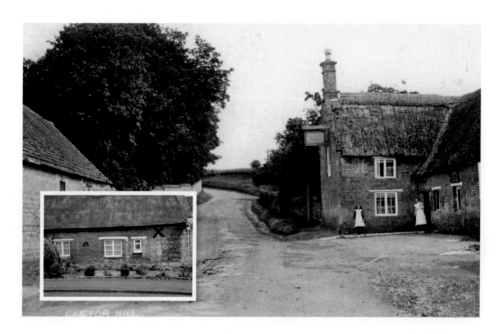

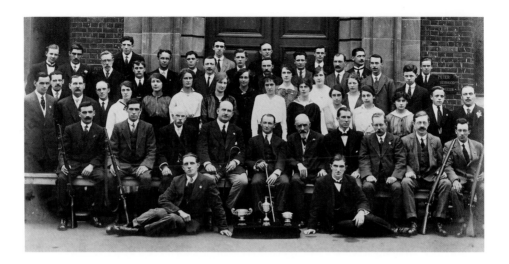

Peter Brotherhood's Rifle Club and Brotherhood Advertisements *c.* 1927

Office workers and board members join the Chairman, Stanley Brotherhood JP, (sitting directly behind the trophies) outside their headquarters at Walton to celebrate the success of the club's wins. Some Board members at this time included Commander Charles Bryant C.B.E., Wheaton Thomas Freestone (Works Manager) and John Burch (Board Secretary). During 1927 large turbines were being built by Brotherhood's for the local Power Station and the company said it was nearly up to its pre-war complement of about 600 at this time. The Chairman, Stanley Brotherhood, lived at Thornhaugh Hall. Messrs. Peter Brotherhood Ltd moved to their works in Walton in 1907. During the First World War they employed nearly 2,000 workers who were employed on munitions, parts connected with battleships, cruisers, torpedo parts, gun parts and tank engines etc. Their staff included naval men of the highest calibre. Not only did they work on projects for The Admiralty during the First World War but prior to that they had received orders from the UK government for oil driven parts for electric generating purposes.

9

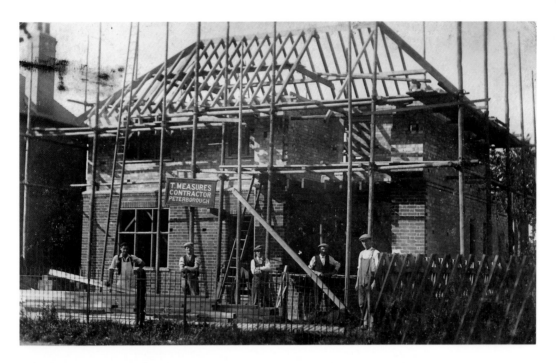

Thomas Measures Building Contractors, *c.* 1927 and John Thompson, Builder

Their offices were in Dickens Street and the house under construction is possibly for a professional working for Peter Brotherhood. The person on the left is Ted Sharpe, a joiner, who lived at 316 Walpole Street. John Thompson senior (who died *c.* 1853) founded a small company of stone and marble masons in Peterborough in the late 1810s/early 1820s. The firm grew, and in 1828 was responsible, working together with Francis Ruddle's joiners & carpenters (who were subsequently taken over), for restoration work to Peterborough Cathedral. The success at Peterborough led to a strong interest in ecclesiastical restoration work, and they did this for at least one-third of the Cathedrals in the UK (including, Chester, Hereford, Lincoln, Ripon, Salisbury and Winchester).

They also repaired (and sometimes built) numerous parish churches (including St Mark's, Peterborough); they made church furniture for even more. Thompson's involved themselves with institutional building, being responsible for Glasgow University; Royal Holloway College, Egham; Selwyn College, Cambridge; and many buildings in Peterborough including the Town Hall, Bridge Street. Furthermore, they built, altered or repaired large country houses: Irnham Hall, Lincs; Flixton Hall, Suffolk; Hever Castle, Kent; Sandringham House, Norfolk; and Durham Castle. John Thompson junior died in 1898 (this is his advertisement in the Peterborough Directory of 1884). He was succeeded by his chief architect, Walter Hill (*d.* 1909) and by his sons, principally Thomas John Thompson (*d.* 1915) and Walter Stuart Thompson, the firm becoming 'John Thompson & Sons Ltd'. Due to financial difficulties they were forced to take no more new work, the goodwill, stocks of materials and equipment were auctioned on 7 September 1938.

John Thompson,
BUILDER,
PETERBOROUGH.

CARVING & SCULPTURE
IN
WOOD, STONE, AND MARBLE.

JOINERY OF ALL **DESCRIPTIONS**
EXECUTED BY HAND OR STEAM POWER.

Tombs, Monuments,
MARBLE & STONE WORK,
AND
All other branches connected with Building Operations
EXECUTED
AND
DESIGNS SUBMITTED.

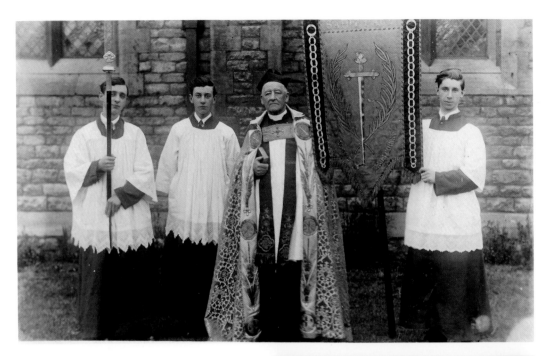

St Paul's Church, Lincoln Road (New England) *c.* 1920s

Here is the Reverend Canon Arthur Fairclough Maskew (*b.* 1854 *d.* 1938) with William Read on the left. St Paul's was consecrated in 1859. The church was built on land given to the ecclesiastical commissioners and cost £4,600 – of which £3,500 was given by the directors of the Great Northern Railway. It was erected to serve the large railway community of New England then growing apace. The church was known as the railwaymen's church.

Interior of St Paul's *c.* 1941

St Paul's church is constructed of stone in the Early English style of architecture. It has an apsidal (rounded) chancel, clerestoried (windowed) nave of five bays, aisles, a west porch and a low central tower with pyramidal roof, containing one bell. There is a handsome oak screen made by John Thompson and erected in 1907. Some say this is the redeeming feature of an otherwise plain church.

ST PAULS, PETERBOROUGH.

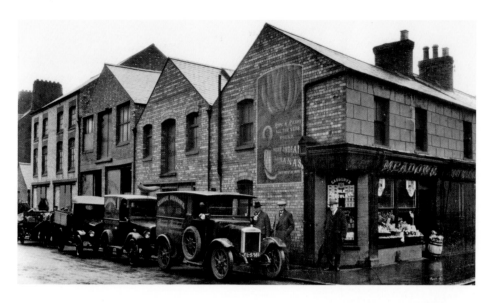

Meadows Shops at 41 Lincoln Road and 21 Cowgate, *c.* 1927 and 1928 respectively

In a Fruit Journal of 1927 George Meadows is described as a gardener at Werrington, who came to Peterborough Market with twenty-five bunches of "Canaries" (small bananas from the Canary Islands) to sell. It's recorded that initially he had a great deal of difficulty disposing of these bananas in Peterborough. In fact, he had to inform customers of the correct way to eat this exotic fruit. The banana must have caught on as his business rapidly grew to the extent that George was selling 1,800 bunches (equivalent to 450,000 individual bananas) in a week. His calling card described him as a general fruit salesman and commission agent – supplying every kind of fruit from England and the Colonies. The premises at 41 Lincoln Road (at the corner of Geneva Street) had some small scale ripening rooms. However at 66 Westgate, George Meadows had six air tight thermal rooms to ripen the bananas (imported from the West Indies, Canary Islands, and elsewhere), and it was thought that these premises in 1927 had the best up to date thermal chambers in Britain. In 1969 there was an explosion causing fatalities at the Westgate warehouse. A fleet of vans, along with horse and carts (pictured overleaf in Geneva Street), would have made deliveries within Peterborough and its surrounding District.

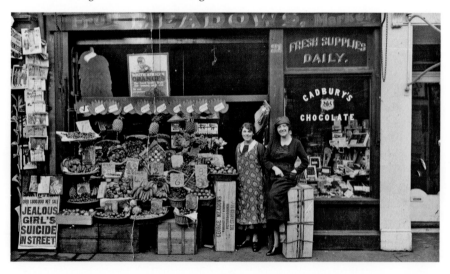

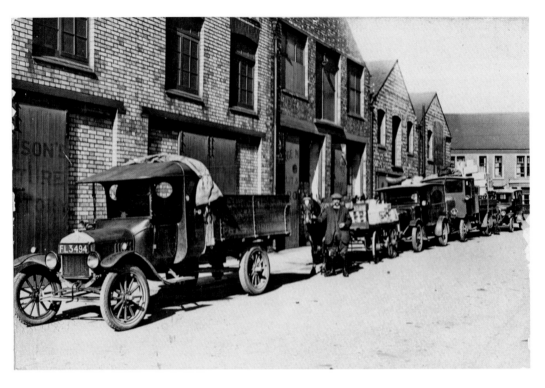

J. W. Morton, 36 Westgate in 1924

One premise that Meadows might have supplied bananas to is James William Morton's high class fruiterer and florist shop. Apart from the wonderful display of fruit displayed in the window – all part of a well balanced diet – Morton's also sold Cadbury's chocolate.

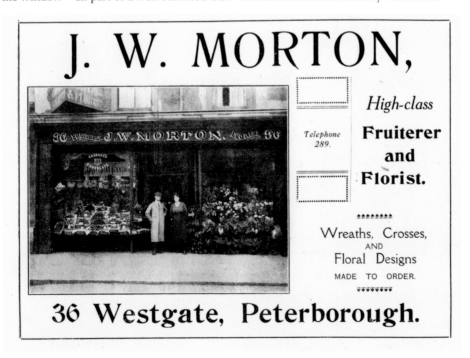

J. W. MORTON,

High-class

Telephone 289.

Fruiterer
and
Florist.

Wreaths, Crosses,
AND
Floral Designs
MADE TO ORDER.

36 Westgate, Peterborough.

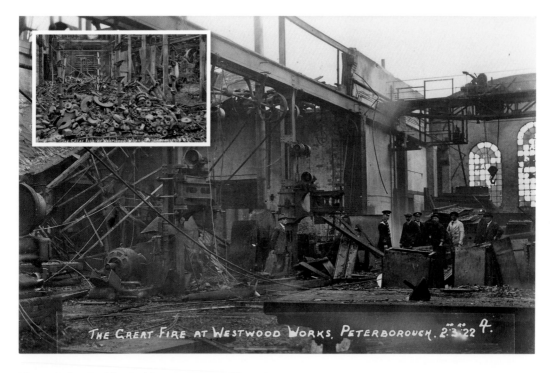

The Great Fire at Westwood Works, Peterborough. 2.3.22 4

Fire at Baker Perkins Ltd in 1922

These four postcards illustrate the extent of the damage caused after a fire broke out at the Westwood Works of Baker Perkins in Westfield Road. The fire was spotted by the night watchman, Joseph Cooke, at 2.15am on 2 March 1922. At about 4am the fire was made worse by an oxygen cylinder exploding. The City and Volunteer Brigades attended the fire along with Old Fletton and the Midland Railway Fire Brigades. Water pressure was found to be low so

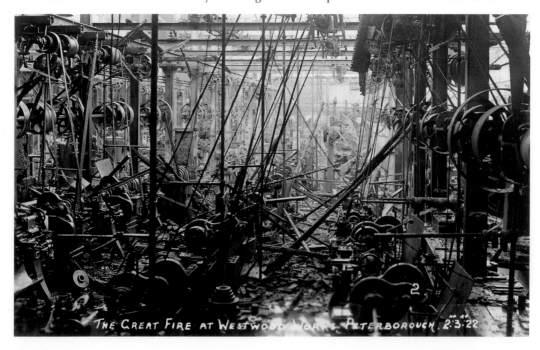

The Great Fire at Westwood Works, Peterborough. 2.3.22

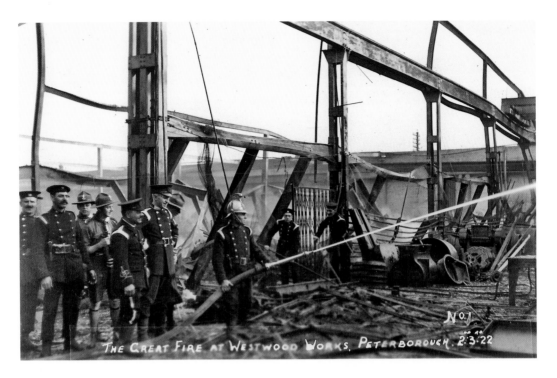

THE GREAT FIRE AT WESTWOOD WORKS, PETERBOROUGH. 2·3·22.

the council surveyor telephoned the Etton and Braceborough Waterworks to get the pressure increased – enabling fire crews to extinguish the fire by 6am. This event is recorded as one of the city's largest fires – others include the fire at the Infirmary (presently the Museum) which occurred in 1884 (without loss of life) and another is the fire in 1956 (pictured below) which completely destroyed Robert Sayle's shop in Cowgate.

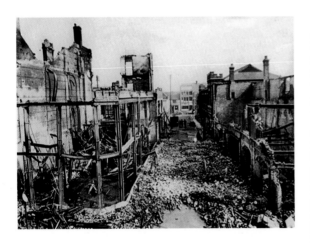

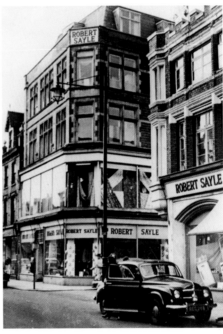

WITH BEST WISHES
FOR
· · CHRISTMAS AND THE NEW YEAR ·
FROM

R. A. F. STATION.
PETERBOROUGH.

ROYAL · AIR · FORCE

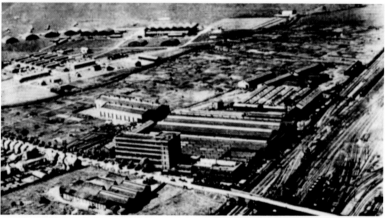

RAF Station Peterborough (1932–1964)

The flat open countryside around Peterborough made an ideal location for airfields and throughout the Second World War pilots were trained at RAF Peterborough (or Westwood), established in 1932 on the outskirts of the city centre. A flying accident occurred at RAF Westwood on 16th April 1936 in which Air Cadet Harold Eric Smith-Langridge was killed along with the pilot Flt. Lt. Ernest Dawson. Two RAF personnel on the ground were also killed when struck by the aircraft, namely Percy Cuthbert and Stanley King, who died the following day. The aircraft was performing its second loop at 300 feet and suddenly hit the ground, crashing into a hanger. It seems the fire also destroyed an Avro Tutor and 3 Audax's. The court of inquiry stated that the probable cause of the crash was due to the pilot, Flt. Lt. Dawson, being drunk. Pictured above is a rare Christmas and New Year greeting card from RAF Westwood.

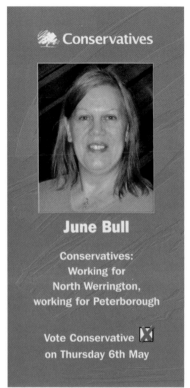

Conservatives

June Bull

Conservatives:
Working for
North Werrington,
working for Peterborough

Vote Conservative ☒
on Thursday 6th May

Election Card 1905

Councillor John Herbert's election card for East Ward saying that he and his fellow Councillor, Thomas Crosby Lamplugh (Mayor in 1906, 1912 and 1922), apologise for not being able to see all 2,059 electors but send this postcard in which they reiterate that they have held meetings giving an account of their past work, and also restated their political views. They also say they understand the work of the Council, and know the needs of the ward and if re-elected they will assure voters that they will continue to watch their interests in all matters; and it's a pleasure for them to repeat that the general rates are 1 shilling in the pound less than when they were elected three years ago. John Herbert (clothing manufacturer) and Thomas Lamplugh (wholesale merchant) sign themselves off to the constituents as 'your two old and experienced servants'.

Canvassing Card

A canvassing card for the local elections in Werrington North on 6 May 2010. Interestingly, the candidate gives similar assurances as that specified by Messrs Herbert & Lamplugh over a century ago.

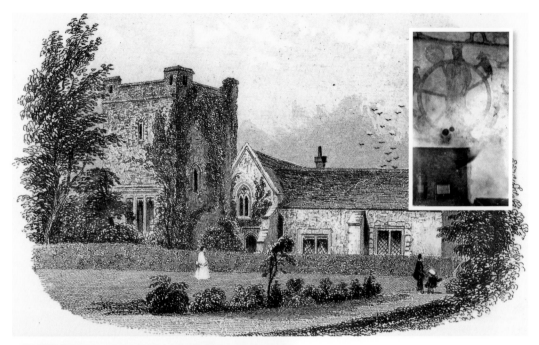

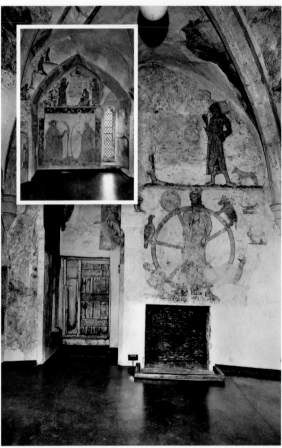

The Old Tower c. 1856

The Tower and house date from around the mid thirteenth century and was a farmhouse for about 500 years. The last agricultural occupier was Hugh Horrell and it was he who found the famous wall paintings when decorating. The wall paintings, said to be the most comprehensive in any small medieval building in England and possibly Europe, display a range of biblical, monastic and secular subjects. The Tower was given to the nation by Captain Fitzwilliam under the Ancient Monuments Act 1913. The Tower is now the responsibility of English Heritage. The Tower house itself was sold in 1981 along with a single building plot for a bungalow to be built. The remaining agricultural buildings, previously part of Tower Farm and Tower House were sold separately for conversion to private dwellings.

Longthorpe Tower, 1951 and 1970

The East Wall showing the wheel of senses – depicting a monkey, vulture, spider's web, boar and cock.

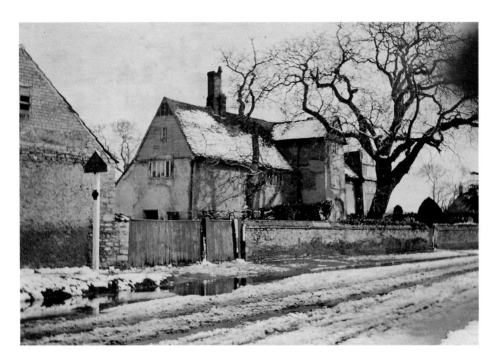

Longthorpe 1916

This is a postcard view of "The Old House" built around 1560 which was a large three storey house at 334 Thorpe Road. It had 32 feet high chimney stacks made of stone. The framework was built of English oak and wattle and daub walls that enabled the house to be warm in the winter and cool in the summer. The front porch was about 9 feet square and rose up through all three floors. The ground level provided the entrance and on the second and third floors were small bedrooms. A massive walnut tree stands in the front garden that is taller than the house. On Monday 16 March 1970, whilst the tenants were away, a massive fire took hold and the roof and upper floor were completely gutted. This listed building and its ancient walnut tree could not be saved due to the cost of restoration. Today "The Leys" occupies the land on which "The Old House" and its huge rear garden and stables stood.

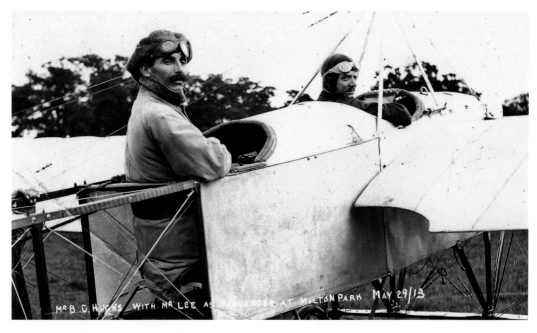

Mr B. C. Hucks with Mr Lee as passenger at Milton Park May 29/13

Pilot B. C. Hucks with a Passenger and Flying Over the City in 1913

A monoplane, piloted by Mr Hucks, with a Mr Lee as a passenger taking off from Milton Park estate – the home of Earl Fitzwilliam. The same plane is flying over Peterborough city centre on 29 May 1913. An aerial view of the city at this time is extremely rare. To encourage British aviation, the *Daily Mail* newspaper offered prizes for air races and first flights between major towns and cities in Britain. A pilot named Mr Ewen was the first airman to land in Peterborough on 29 June 1912.

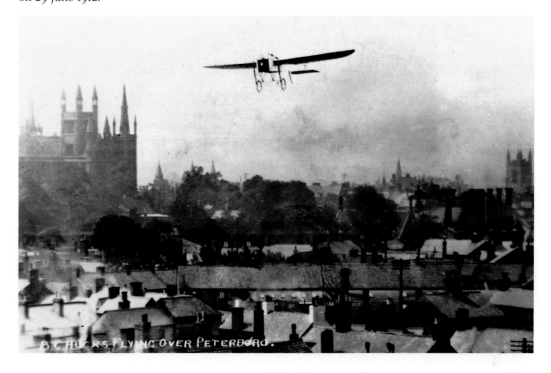

B C Hucks flying over Peterboro'.

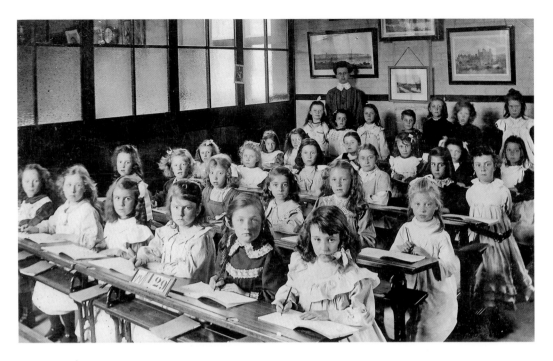

Cromwell Road Infants' School, Beech Avenue, c. 1910

This was a council run infant school that opened in 1908 with 240 girls and there was an elementary school for 210 girls on the same site. The Head Mistress for the Infant School was Miss Julia Potts, who lived at 74 Granville Street. The house in Granville Street where the Head Mistress lived, still stands today, as shown below and is named West View. A fine example of a late Victorian semi-detached house, built in 1895.

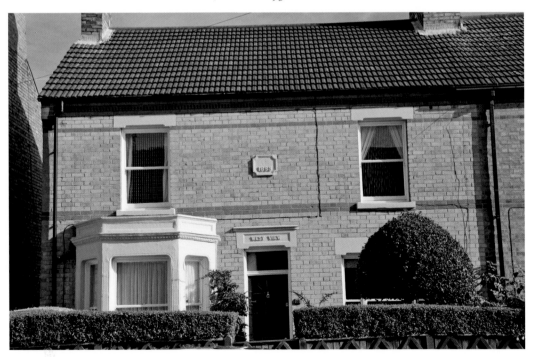

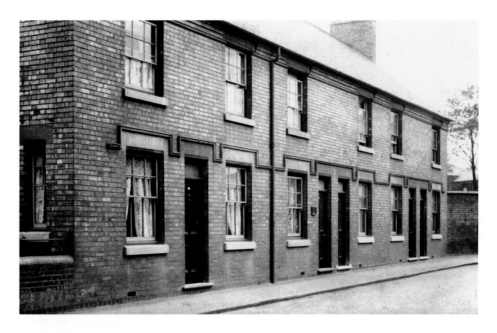

Towler Street looking from St Mark's Street, *c.* 1905

This is Towler Street taken from St Mark's Street and shows Nos 2, 4, 6, 8 and 10 from left to right. It was formerly named Christian's Road prior to the 1890s because of its proximity to St Mark's church. The street linked Lincoln Road East (now Burghley Road) to St Mark's Street. The occupants at the time of this postcard were No. 2 Mr John Bill; No. 4 Mr Gee; No. 6 Mrs Storey; No. 8 Mr John Harper and at No. 10 lived Mr Arthur Bass. The view today shows that little has changed over the past 105 years. The street was named after a local builder, William Towler, who had his yard in Towler Street but his office and home were in St Mark's Street.

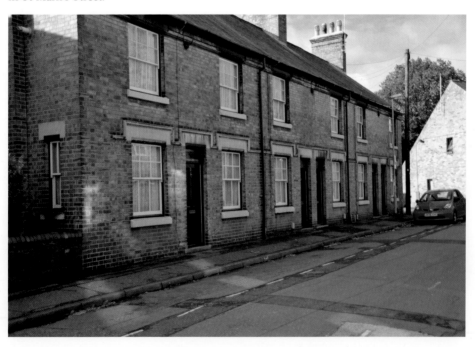

Mr John Sutton of 'Sutton the Carriers'
c. 1898

His business initially started in Westwood Street but he later had offices at 8 Station Road – being the LNER goods agent working out of East & North Stations and New England. He would take and collect parcels from the railway stations and then deliver them to businesses in and around the town. When he was established he employed a Mr Harry Miles who lived in Fitzwilliam Street. John Sutton would have delivered by horse and cart but today's express packet and parcel service is by van. This belongs to a Peterborough Courier who offers the same day service and the most secure solution for all urgent delivery requirements from important documents to urgent delivery of parts and pallets across the UK.

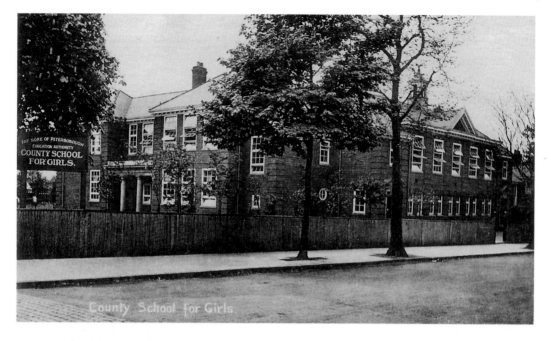

County School for Girls, Corner of Lincoln Road and Cobden Street, *c.* 1920s

The County School for Girls was built in 1911, on a site of about 1½ acres, and opened by the Marchioness of Exeter. The Junior School had premises opposite the school which provided six large additional classrooms and a cloakroom. In 1920 one of its pupils gained a State Scholarship – which at that time was one of the most valuable of all University Scholarships. In 1921 it headed the list of Girls' Schools in the Oxford Higher Certificate of Education. In 1924 three open scholarships were given at Girton College, Cambridge University for Mathematics and at the Royal Holloway College for Classics and Somerville College, Oxford University for History. The School was a member of the Fenland Public Schools League for Hockey and Tennis.

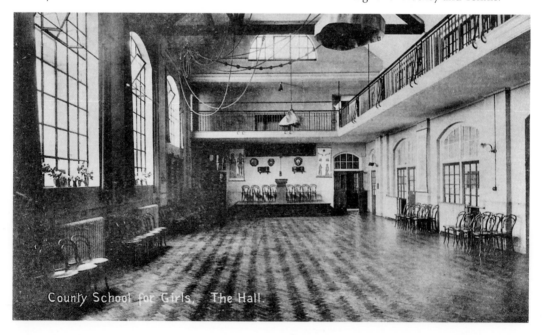

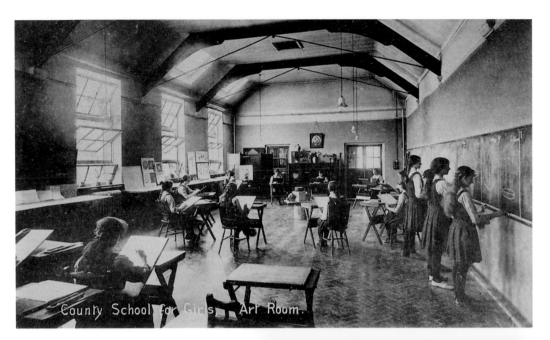
County School for Girls, Art Room.

It won the Tennis Cup in 1921, 1923, 1924 and 1925. The Head Mistress in 1927 was Miss Wragge, Second Mistress, Miss Hough and the Head Mistress of the Junior School in 1927 was Miss Smart. The County School for Girls that became a girls' grammar school was demolished to make way for Lincoln Gate, a block of warden-controlled flats, in the late 1980s. The Boarding School (run separately as a private concern) was located at "The Lawns", Thorpe Road, where the Registry Office is now. During the First World War the school raised money for the upkeep of two Belgian refugee families in the city. The plight of the Belgians who were made homeless at the beginning of the First World War inspired the Mayor of Peterborough, Sir Richard Winfrey MP, to launch a public appeal for money, furniture and clothing. Untenanted houses were taken over and converted into hostels. The first Belgian refugees arrived on the 13 September 1914 and over a dozen hostels were opened to house them all. The Mayor's Appeal Fund raised £2,000. After the war all refugees were sent back to Belgium.

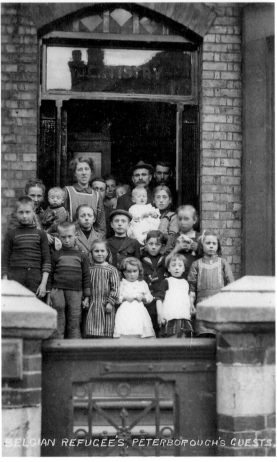
BELGIAN REFUGEES, PETERBOROUGH'S GUESTS.

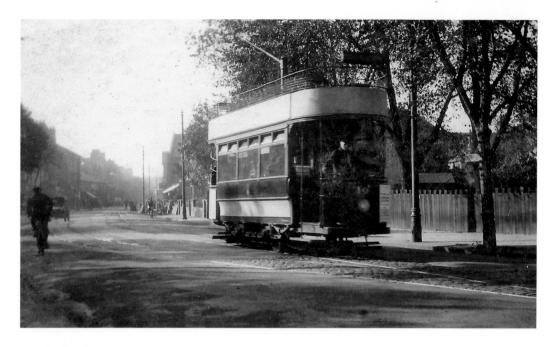

Lincoln Road c. 1930

This is Car 10 run by the Peterborough District Electric Tram Company making its way out of town. It's about to pass St Mark's church just out of sight in the right foreground. Car 10's terminus was at Walton. Electric tramways succeeded the horse buses in 1903 and operated in Peterborough for twenty-seven years. By way of recreation tram rides would be taken to Walton from where one could walk to Werrington or Marholm Woods. The only things identifiable today are all the trees on the right hand side that now block the view of St Mark's church.

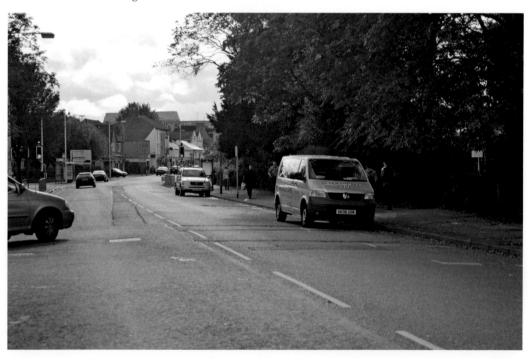

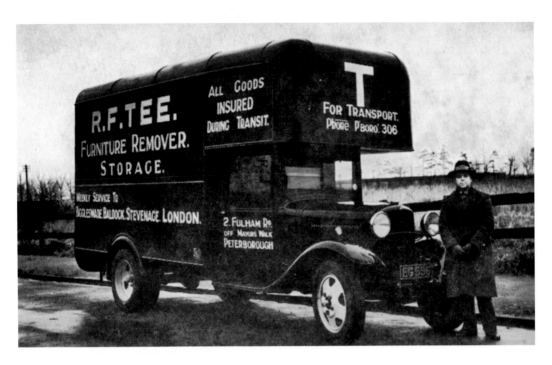

R. F. Tee Furniture Removal Van, _c._ 1942

Reginald Tee set up a removal business 'T for Transport' at 2 Fulham Road, West Town, which would remove or deposit your furniture. The company provided a weekly service to Biggleswade, Baldock, Stevenage and London. In the early 1960s the company moved to 67 Taverners Road. The only sign that the latter property could have been a business is the large entrance to the left which is where the lorries would have entered the back yard.

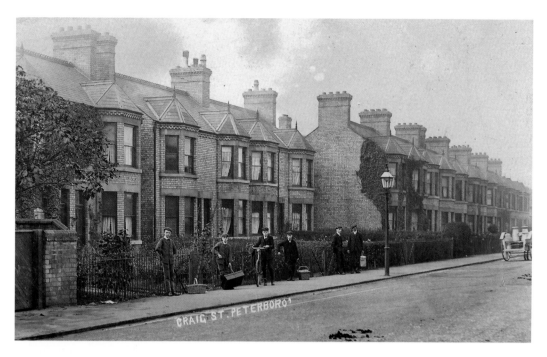

Craig Street *c.* 1909

A splendid postcard depicting an array of delivery boys, some are holding bread baskets and others grocery boxes with the end two carrying milk churns. It looks as though the horse-drawn milk cart has left some of the horse's belongings in the road! Nowadays little has changed apart from the front gardens being used as car parking spaces and the removal of the street light.

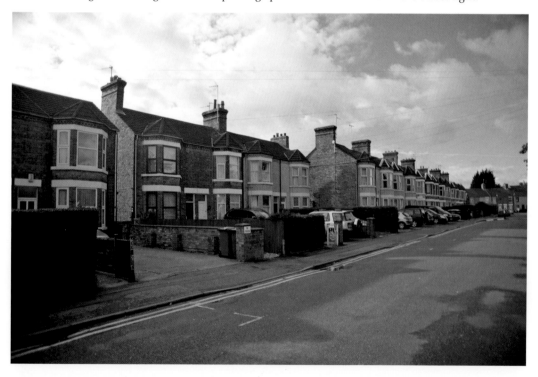

Monks Barn, situated between Manor House Street and Church Walk *c.* 1904

Known as the Boroughbury (the local term for the town end of Lincoln Road) Barn, it was originally a tithe barn (400 feet long and 40 feet high) which was in use up until 1898. The barn was built by Abbot Adam of Boothby and made completely of oak with stone rubble walls. It survived both the Reformation and the Civil War. In 1904 it was carefully dismantled and some of the stone was used to construct Rothesay Villas. No. 63 has been a long standing GP's surgery. The wood came from Rockingham Forest – the same source that was used in the Cathedral.

Rothesay Villas, Lincoln Road

The recycled stone from the Monks Barn is very noticeable in this row of three-storey houses. Many of these houses are now business premises and No. 63 (second door from the right) has long been a GPs' surgery.

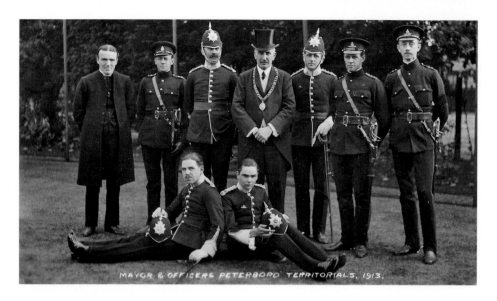

MAYOR & OFFICERS PETERBORO' TERRITORIALS, 1913.

Territorials at Gayhurst, 80 Lincoln Road in 1913

Mayor John Golby Barford JP poses with officers from the Yeomanry and the Northamptonshire Territorials in the garden of his home at Gayhurst in June 1913. One of the Commanding Officers of the Territorials was Capt C. A. Ralph Smith who was awarded the Military Cross and Bar. He served in France from September 1914 to May 1919. It is believed that the gentleman on the left is the Vicar of St Mark's.

Non Commissioned Officers of the Northants Battery, Royal Field Artillery in 1913

These officers are pictured with Mayor Barford in the grounds of his private home, Gayhurst, in July 1913. Recently new plans have been submitted to City Council planners to construct twenty-five homes on the historic site of this 130-year-old building renamed Thurston House. Proposals to preserve the front and the sides of the building are likely to be approved. Gayhurst was built in 1873 for William Barford, who was a Director of what was later to become Barford Perkins Engines Ltd. Barford was dropped from the name at a later date, creating the company we know today. The property passed through the family until the start of the Second World War when it became a Civil Defence Headquarters. After being used by the Civil Defence, Gayhurst went on to become offices for the planning department of the City Council from about 1975 to 1984. In this picture can be seen the wooden summer house in the corner, which no longer exists and the large grassed area in front of the house, seen here, was a popular sporting location for tennis and lawn green bowls.

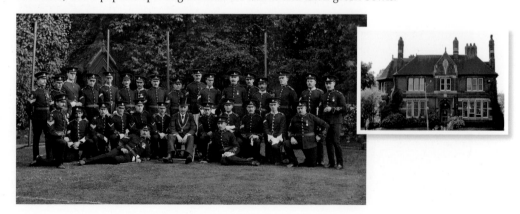

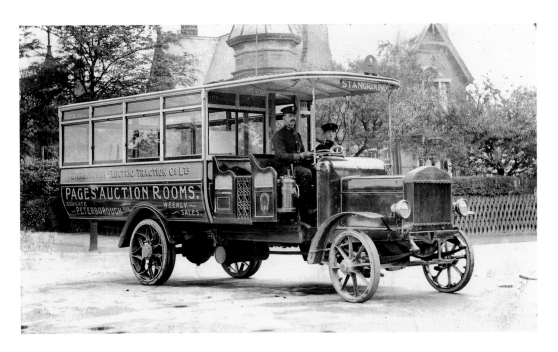

Broadway *c.* 1914

Owned by Peterborough Electric Traction Company, with its distinctive bodywork by Brush of Loughborough, this is a 26-seater Straker-Squire bus *en route* to Stanground. It is travelling down Broadway towards the city with the junction of Crawthorne Road on the right. Today's modern larger bus is pictured turning from Burghley Road into Broadway with the junction of Crawthorne Road to the right. The building in the background is the Conservative Club.

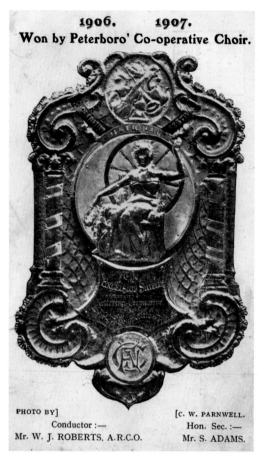

Shield won by Peterborough Co-operative Choir in 1906/7

This Co-operative National Festival Excelsior Shield was awarded to the Peterborough Branch from the previous competition winners – Kettering Co-operative Choral Choir. The Co-operative Musical Society had a junior and senior choir and they would practice in the Co-operative Hall, Park Road, every Monday evening. The hall was 50 feet long by 41 feet wide and could accommodate seating for 740 people. The Assembly Room was on the first floor with nearly half the capacity of the main hall. The main hall had a "Broadwood" piano. The conductor of Peterborough Co-operative Choir in 1906/07 was William James Roberts ARCO, music master and organist, of 51 Park Road.

Fancy Dress Ball at Co-op Hall in 1918

The Co-operative Hall was the Area Headquarters of the Trades & Labour Council, and the Unionist Club used to meet in the hall before moving to 77 Broadway, now known as the Conservative Club. On 6 February 1918, a fancy dress ball was held with an imaginative range of costumes, seen in this photograph, considering that the First World War was yet to end. After the Second World War, the hall was converted to a restaurant.

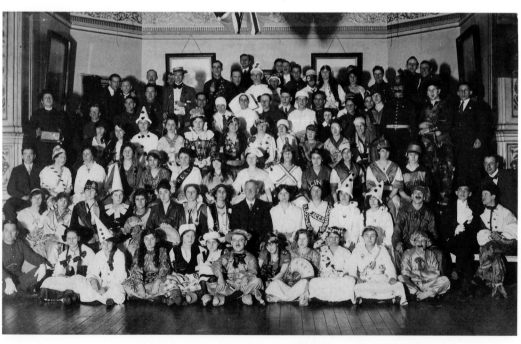

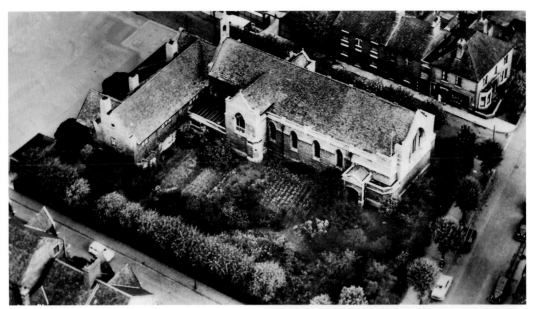

All Souls Roman Catholic Church, Corner of Park Road and Fitzwilliam Street c. 1950s

The church was designed by Leonard Stokes (one time President of the Royal Society of Architects), and the foundation stone was laid on 26 November 1895. It was opened in incomplete form on 15 October 1896 with two remaining bays, north and south porches and Baptistry to be built. When all works were complete it was ceremoniously opened on 19 May 1904. It is floated on a bed of concrete and steel as part of the site which used to be Boroughbury Ponds. All Souls' church and Rectory is the successor of the church of the Holy Family founded by Canon Seed, which was opened in Queen Street on 11 October 1856 – being the first Catholic Church in the city since the Reformation.

Interior of All Souls Roman Catholic Church, c. 1917

This view is looking towards the Altar. More recently, the church interior has been redecorated and refurbished.

The church was built over the old Abbey fishponds, with the structure being floated on a two and a half feet thick raft of concrete. The presence of underground water is evident today in the thriving willow tree in the garden.

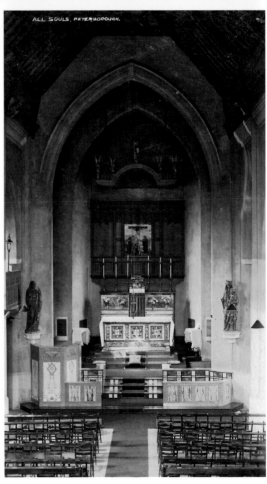

ALL SOULS, PETERBOROUGH.

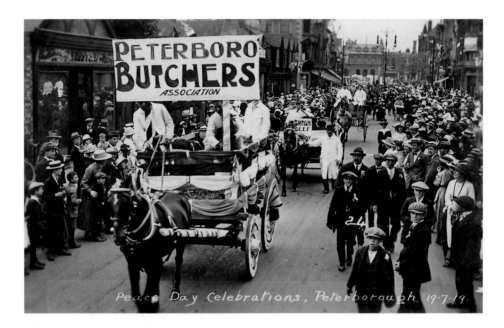

Peace Day Celebrations, Peterborough 19.7.19.

Long Causeway, July 1919

Photographed from the beginning of Broadway, near the junctions of Midgate and Westgate looking south down Long Causeway – this postcard is one of a series depicting the Peace Day Parade held on 19 July 1919. Businesses, trade associations and the like all took part by entering a float and here is the contribution by the Butchers' Association. This organisation had its headquarters at the Angel Hotel, Narrow Bridge Street. It was established in 1902 for the protection of members and to further trade interests, and to compensate members for loss of meat surrendered to Local Authorities. The only reference point visible today is the building to the right which was T. L. Barrett's shop on the corner of Westgate. The trees cut out the view of the HSBC Bank (formerly Midland Bank) in the background.

Aerial View looking West from Cumberland House, *c.* 1960s
Looking down from Cumberland House, Chapel Street can be seen in the right foreground with New Road centre right. The garage of Peterborough Motors, the main Ford dealer, can just be seen two thirds up on the right hand side; whilst top left is the Embassy cinema.

Aerial View of the Peterborough City Hospital, Bretton Gate
Hospital bosses offered guided tours in October 2010 around the new 612-bed, four-storey Peterborough City Hospital in Bretton Gate. The hospital is replacing facilities at both Edith Cavell and Peterborough District hospitals. It is the largest building project seen in the city since the cathedral was built more than 800 years ago and marks the final piece in the jigsaw that forms the £335m Greater Peterborough Health Investment Plan.

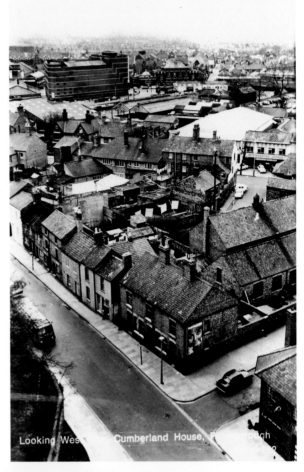

Looking West from Cumberland House, Peterborough

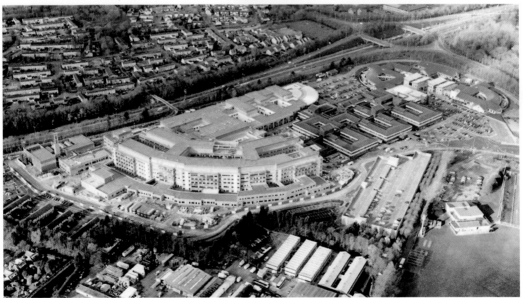

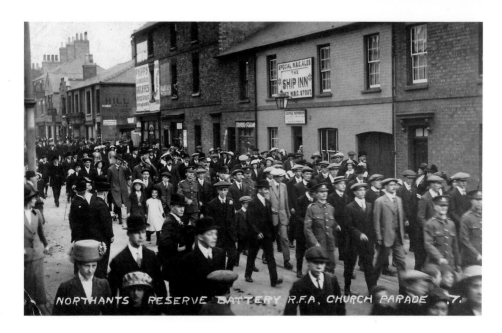

NORTHANTS RESERVE BATTERY R.F.A. CHURCH PARADE .7.

New Road, Sunday 25 October 1914
Parading down New Road with Chapel Street junction in the background and the Ship Inn pub located at 18/20 New Road these men of the Northants Reserve Battery Royal Field Artillery are marching towards Midgate. They are either making their way to the Cathedral or Peterborough Parish Church – St John the Baptist for Sunday service. This whole area today is completely unrecognisable and has been totally redeveloped into solely commercial properties. On the immediate right is the Passport Office which consumed the site of the Ship Inn. In the centre can be seen the entrance to Chapel Street. The large blue building is a Travelodge and Indian restaurant.

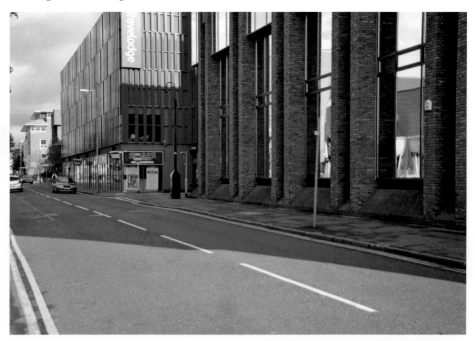

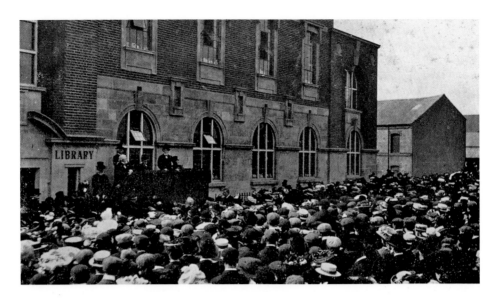

Andrew Carnegie Opens the Public Library, Broadway, in 1906

As far back as 1891, Dr Thomas Walker (an eminent local surgeon) presented a public petition asking that the council set up a public library in the city. Eventually the Public Library Act was adopted on 10 March 1891, and a library was fully established by April 1893, in an adopted building in Park Road. The original library in Broadway (now Imperial Bento, Chinese Restaurant) cost £6,700 and was wholly funded and presented to the city by Andrew Carnegie. The library had a reading room, reference library, lending library and a children's library and reading room. On 29 May 1906 the official opening of the library (completed in December 1905) was performed by Mr Andrew Carnegie, who on the same day was presented with the Freedom of the City. Mayor Lamplugh was also in attendance.

Carnegie was born in Dunfermline, Scotland, on 25 November 1835 – the son of a handloom weaver. The economic depression of 1848 convinced the Carnegie family to emigrate to America. Andrew began work at the age of twelve in a cotton factory but continued his education at night school. He made regular visits to Britain where he observed the rapid developments in the iron industry and quickly realised that steel would now replace iron in heavy goods manufacture. Carnegie invested heavily in this new industry and became a very wealthy businessman. It was this wealth that funded his philanthropy. Carnegie strongly believed that education was the single most important route out of poverty and opened 660 libraries in Britain and Ireland. The Carnegie United Kingdom Trust was founded in 1913 with an endowment of $10 million. It remains a registered charity under Scottish law today and in 2008-09 had a gross income of £1.9 million, down £0.8 million on the previous year.

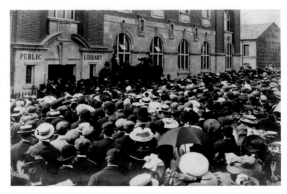

37

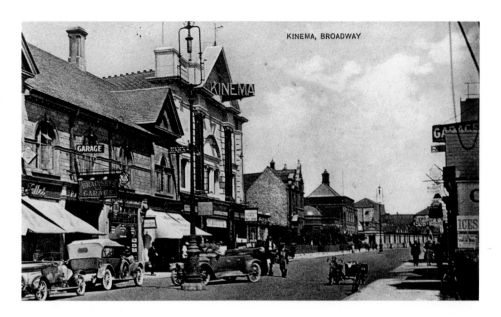

Broadway, c. 1927

Broadway was the entertainment district. On the left can be seen The Kinema which used to be the Gaumont which opened on the 17 December 1910 and the proprietor was Mr G. Fitzwilliam and the lessee was Arthur Gale. The architect was Alan Ruddle and it had 700 seats. The building was extended in August 1913 to include a balcony and new façade and it was renamed the Kinema which could accommodate seating for 1,560 people. Talking pictures came on the 16 September 1929 with the showing of *Movietone Follies*. In c. 1952 it was fitted with 'Ardente' deaf aids and it had wide-screen and 3-D Cinemascope. It returned to being called the Gaumont on the 5 November 1961. The theatre eventually closed to film on the 18 October 1963 with the final showing of – *It's All Happening* and *Watch It Sailor!* The building was demolished October/December 1983. Just before the Kinema on the left is Brainsbys garage that boasted of accommodation for 150 cars and was an agent for Rolls-Royce, Daimler, Humber, Wolseley, Arrol-Johnson, Standard, Citroën and Fiat cars. They also provided chauffeurs and car hire.

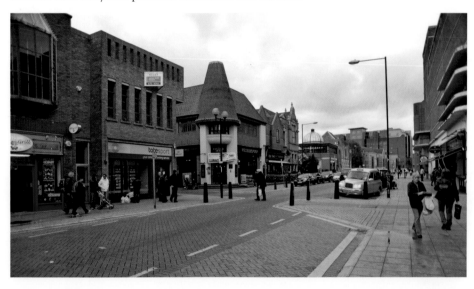

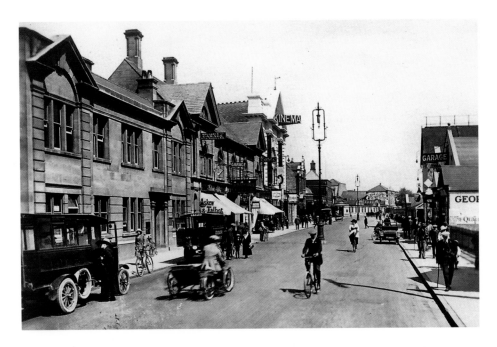

Broadway Photograph c. 1916

An array of transport can be seen in this lively view of Broadway looking out of town. The Broadway Garage entrance can be seen after Askew & Talbot's shop. The Kinema sign is in the left background and the Theatre Royal & Empire is way in the background – past the second lamppost. Presently, there are no cinemas or theatres in this area but it remains a shopping area. In the distance can be seen the old library (now Imperial Bento, a Chinese restaurant) followed by the new library, then the offices of Hegarty Solicitors at 48 Broadway.

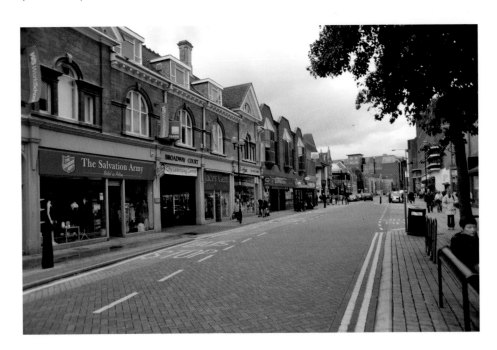

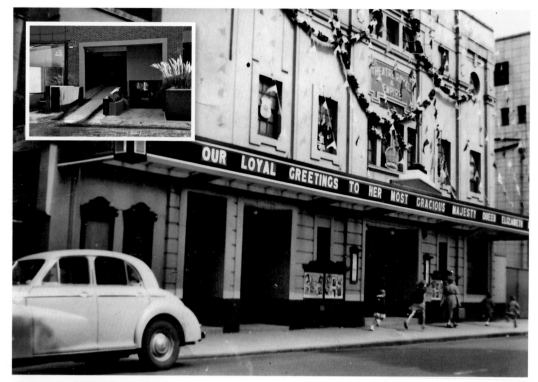

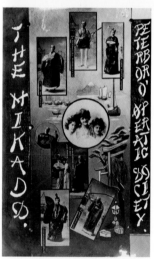

Theatre Royal & Empire, Broadway on 2 June 1953

Like the rest of the United Kingdom – the whole of Peterborough was decked out in bunting for the Coronation of HM Queen Elizabeth II. The Coronation usually takes place several months after the death of the previous monarch, as it is considered a joyous occasion that would be inappropriate when mourning still continues. This also gives planners enough time to complete the elaborate arrangements required. Elizabeth was crowned in Westminster Abbey on Tuesday, 2 June 1953, despite having acceded to the throne on Thursday, 6 February 1952, the instant her father died. British law states that the throne is not left vacant and the new monarch succeeds the old immediately. By way of commemoration, licensing extensions to permit all day opening of public houses was granted on this day and numerous street parties and civic events took place in Peterborough and in the rest of the UK.

The Theatre Royal & Empire closed on 29 November 1959 and was demolished in 1960/61 when Shelton's Department Store was built on the site. Shelton's was eventually demolished in the 1990s. The Holistic Health Centre, "Garden of Eden", 62 Park Road, (inset) occupies the ground floor of the new development at the former Shelton's department site.

Peterborough Operatic Society c. 1904

This is a production of *The Mikado* by the Peterborough Operatic Society in 1904. The following year they performed *Merrie England* and *The Mikado* was performed again by them in 1922. Subscription was 5 shillings per annum. The Society was affiliated to the National Amateur Operatic and Dramatic Association.

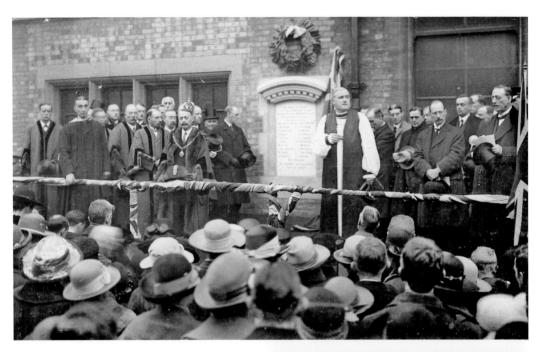

Unveiling and Dedication Service
c. 1919
Bishop Woods performs the unveiling of the memorial with Mayor Charles Vergette standing to the left of the memorial – wearing his chains of office.

Post Office War Memorial
This is a memorial to all those Peterborough & District Post Office staff who never returned from the First World War. The names of twenty members appear on the plaque which was erected in Cumbergate – now under Queensgate shopping centre. The memorial is currently housed in the Museum.

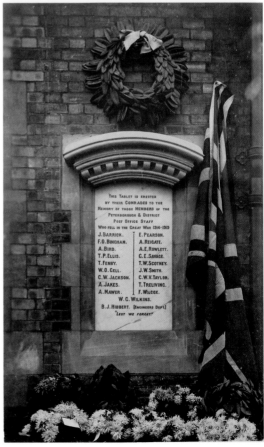

THIS TABLET IS ERECTED
BY THEIR COMRADES TO THE
MEMORY OF THOSE MEMBERS OF THE
PETERBOROUGH & DISTRICT
POST OFFICE STAFF
WHO FELL IN THE GREAT WAR 1914-1919

J. BARRICK.	E. PEARSON.
F. O. BINGHAM.	A. REIGATE.
A. BIRD.	A. E. ROWLETT.
T. P. ELLIS.	C. E. SAVAGE.
T. FENBY.	T. W. SCOTNEY.
W. O. GELL.	J. W. SMITH.
C. W. JACKSON.	C. W. V. TAYLOR.
A. JAKES.	T. TRELIVING.
A. MAWER.	F. WILCOX.

W. C. WILKINS.

B. J. HIBBERT. (ENGINEERS DEPT.)

"LEST WE FORGET"

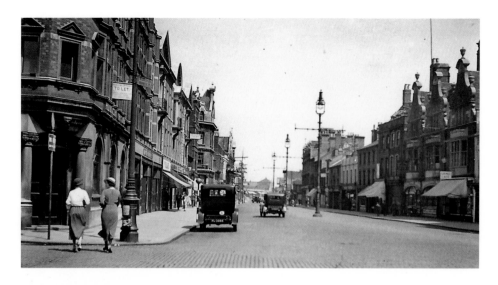

Long Causeway in 1936

Here is a near empty Long Causeway looking north towards Broadway. This was the year of the abdication of King Edward VIII. Only months into his reign, Edward caused a constitutional crisis by proposing marriage to the American divorcée Wallis Simpson. The Prime Minister of the UK and the Dominions opposed the marriage, arguing that the people would never accept her as Queen. Edward knew that the government led by Stanley Baldwin would resign if the marriage went ahead, which could have dragged the King into a general election and ruined irreparably his status as a politically neutral constitutional monarch. Instead of giving up Mrs Simpson, Edward chose to abdicate. He was succeeded by his younger brother, George VI. Edward is one of the shortest-reigning monarchs in British and Commonwealth history, with a reign of 325 days, and was never crowned. However, he was the third and final British Monarch to serve his entire reign as the Emperor of India.

Coronation of King George VI

A year later in 1937 we have almost the same view but it is decorated for the Coronation of King George VI. Notice that the building on the left is now the offices of The Prudential.

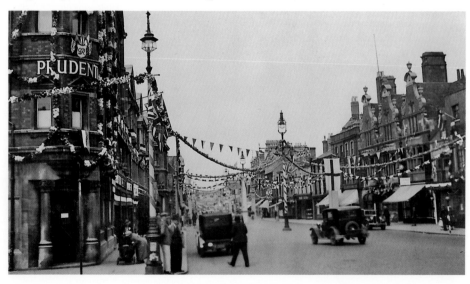

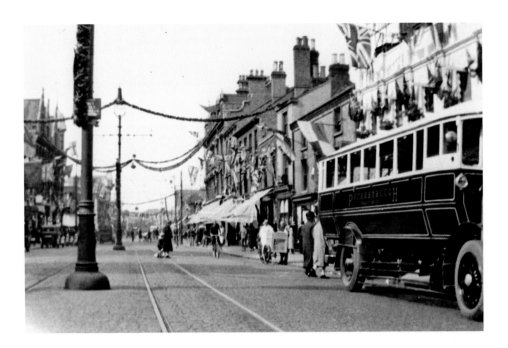

Long Causeway in June 1911

Decked out in bunting and flags for the Coronation of King George V on 22 June 1911. In the right foreground is a Straker-Squire bus and the tram lines to the city centre terminus at the junction of Long Causeway and Market Place (now Cathedral Square). The Straker-Squire company had its works in Angel Road, Edmonton in London. The company was founded in 1901 and originally built steam vehicles. In 1925 and again in 1926 the company went into receivership. The view today is of a tree-lined pedestrian shopping area. One or two of the buildings pictured in the 1911 Coronation celebrations are still standing, and can be identified from the upper floors of the existing shops – albeit very few chimneys have survived.

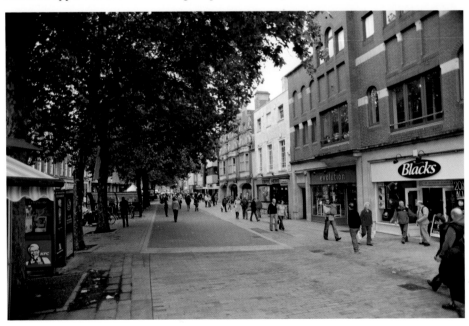

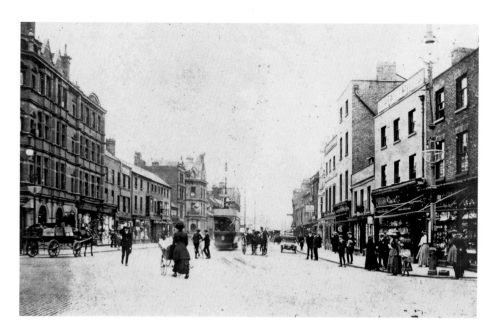

Long Causeway, c. 1909

What a wonderful Edwardian view of Long Causeway from the Market Place. The second shop from the right is Gills China Stores. The entrance in the right foreground would take you to the Cathedral Gateway and the road on the left would take you to Exchange Street. Many Peterborians will recall the firm R. J. Glass, draper's and milliner's, the corner of their premises is in the left foreground of the picture. The tram in the centre is making its way to the terminus having come from Dogsthorpe and Walton. This twenty-first century view shows a busy city centre where the individual shops have been replaced by corporate chain stores. The whole area is now pedestrianised with tree-lined streets and seating areas.

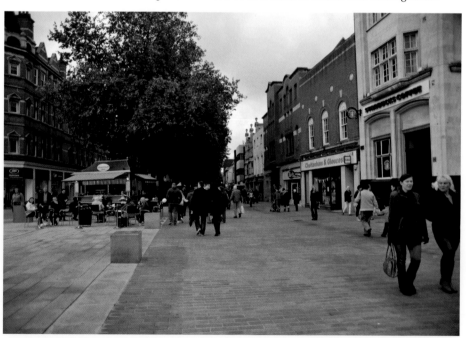

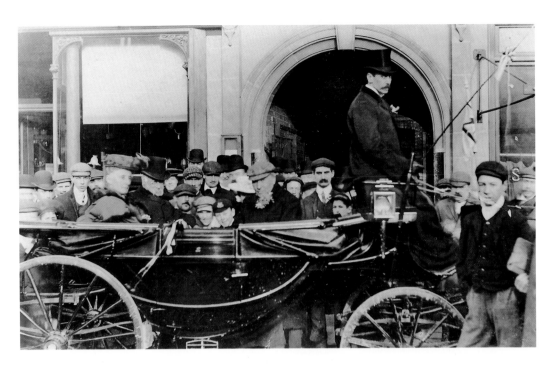

Parliamentary Elections 1906

Here's a postcard of the Tory candidate, Sir Robert Pervis, sitting in the coach with his wife by his side outside Market Chambers. He received 267 votes but lost to the Liberal candidate, George Granville Greenwood who was knighted in 1916.

Greenwood during the 1906 Parliamentary Election

Having won the seat in 1906, Mr George G. Greenwood retained it in the 1910 election – but with his previous majority of 1,150 votes reduced to 303. He is pictured here in his carriage outside Willson's Pharmaceutical Chemist at 6 Long Causeway.

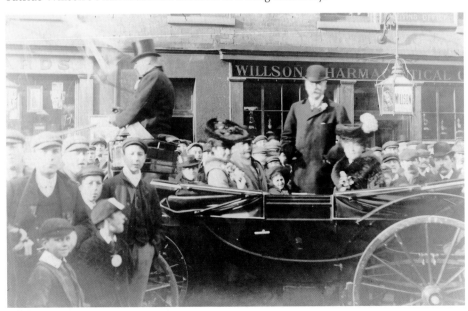

Mr T. A. Tomlin, Market Toll Inspector, c. 1930s

This gentleman was responsible for the collection of market tolls from Cattle Market stallholders in Cattle Market Road, off Broadway, and from market stall holders trading in Market Place (now Cathedral Square). The revenue would go straight to the council and be partly used for the maintenance and upkeep of the areas.

Cattle Market in 1910

The Peterborough Cattle Market Company was formed in May 1863 and was built on part of a field called Simpsons Place. This land (off Broadway) had been bought from Earl Fitzwilliam in 1861. The cattle market used to be held in Long Causeway up until 1866. In 1891 the cattle market was bought by the council and finally closed in the spring of 1972. The general market held in Market Place was relocated to the site of the old Cattle Market in 1963.

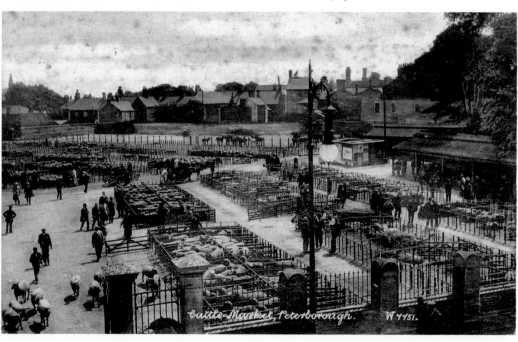

Cattle Market, Peterborough. W 4751.

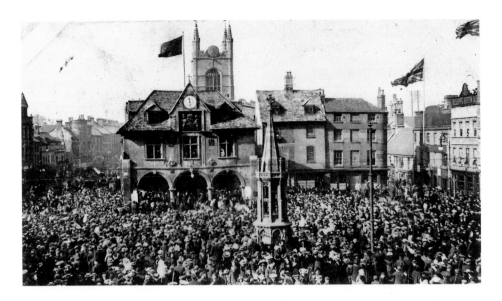

Meet of the Fitzwilliam Hounds, Market Square, in 1904
The Peterborough Foxhound, Harrier and Beagle shows were established about 1887 and
the shows were held annually at the Peterborough Agricultural Show. The kennels were at
Milton Park and the Peterborough dress was a green velvet collar with silver hunt buttons.
This historical meet was in March 1904 and shows how popular this sport was at the turn
of the last century. The meet celebrates the fact that the hounds at Milton were descendants
of the pack that was chief prize-winner at Redcar in September 1859. Also the Fitzwilliam
Foxhound Show was the first to be open to all England, although showing hounds dates
back to the 1760s.

Milton Estate, 1906
The end of a fox hunt in October 1906 where the fox is broken up – notice how many of
the women are looking away. The scene is at Milton Estate somewhere within the 23,000
acres between Peterborough and Irthlingborough.

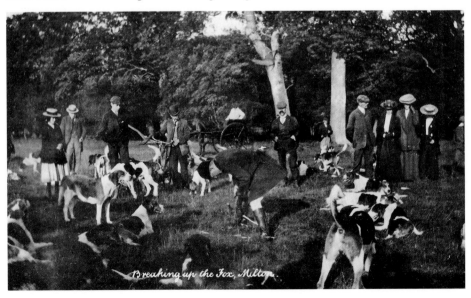

Breaking up the Fox, Milton.

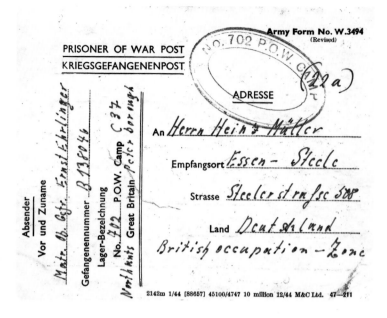

Second World War Prisoner of War Correspondence Postally Used 11 November 1946
This correspondence was sent back to Germany from No. 702 POW camp by Ernst Ehrlinger who was held in camp 37 (Peterborough). The camp was located in Kings Cliff. The sender is writing back home to a friend to let him know how he is and what the conditions are like. He lets his friend know who else is held at the British POW camp.

VE Day Celebration, Market Place, 1945
The sheer jubilation and celebration can be sensed from this real photographic picture postcard. There are soldiers, sailors, airmen and civilians all dancing in the street because war has officially ended in Europe, after six long years of struggle and conflict; finally some sort of normality kicks in. It was to be a few more months before Victory in Japan Day was announced on 15 August 1945. Presumably Ernst Ehrlinger was repatriated to Germany soon after sending his postcard to friends back home.

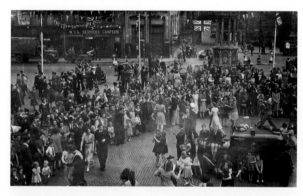
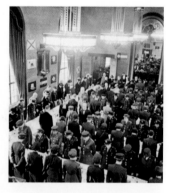

American Servicewomen at Town Hall in 1944
A year earlier in Peterborough Town Hall – Mary, The Princess Royal and Countess of Harewood, was honouring the work of American Servicewomen serving in the local area, by acknowledging their war efforts at a special luncheon hosted by the Mayor, Mr Harry Kelley, JP.

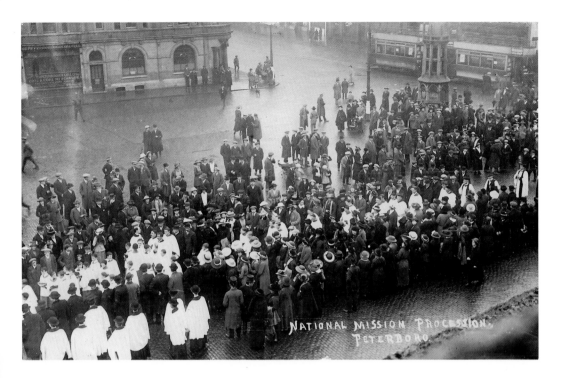

National Mission Procession, Market Place c. 1922
The headquarters of the National Mission Society was in Salisbury Square, London but the local Church Mission Society had a branch from 1905. Its purpose was to provide overseas aid and promote the cause. The Vicar of Peterborough Parish church was the President and the Committee was the Executive Committee of St John the Baptist Parochial Mission Association. At the time of this procession from the Cathedral to St John's church, the Secretary and Treasurer was Miss Swan, Head Mistress of St John's school, Bishops Road. Annual meetings were held in October.

**Reverend Canon Gordon Steele, Vicar of St John's –
Peterborough Parish Church**
The Vicar of St John's in 1922 was Arnold Manvell and the curate Revd C. Fletcher. Revd Manvell can be seen on the extreme right of this postcard. The vicar today is Canon Gordon Steele (right).

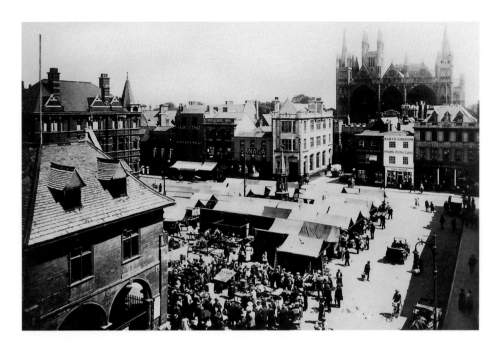

Market Place c. 1929

Now called Cathedral Square from 1964 when the covered market moved to New Road. Originally the Market Place was named Marketstede. At the time this picture was taken the seventeenth-century Guildhall was used as the Town Hall. You can see that the arches of the Guildhall are railed off and that market traders are busy selling their goods.

City Centre

Under the Public Realm project the city centre has undergone a major face lift with fountains added, new seating and York Stone slabs laid. The old Norwich Union/Post Office building was demolished in 2009 to make way for St John's Square to the west end of Peterborough Parish Church. This £11.6 million project has its supporters as well as its detractors.

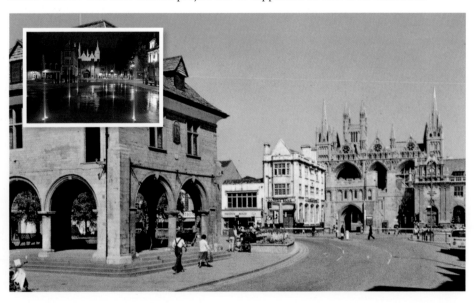

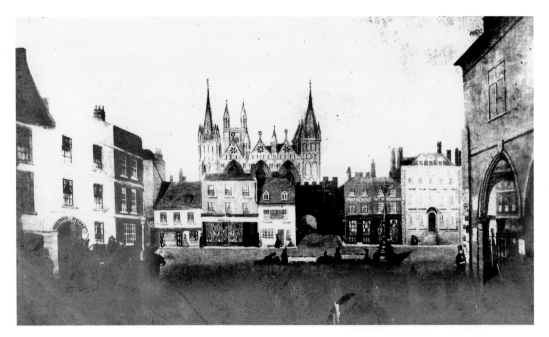

Market Place, 1860s

A rare late nineteenth century view of the Market
Place with the Cathedral prominent in the centre. The
Guildhall is raised on pillars (possibly because it was a
corn store), dates from 1671, and can be seen in the right
foreground. The Posting House is in the left foreground
and was a Coaching Inn, specialising in good food, fine
ales and quality accommodation. The stocks can be seen
to the left of the lamppost which is centre right.

Market Place, 1936

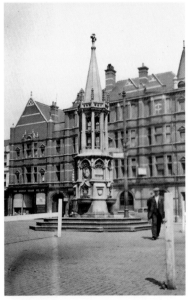

This shows the Gates Memorial Fountain (Henry
Pearson Gates – last High Sheriff and First Mayor of
Peterborough from 1874 to 1876) that was unveiled in
1901 and then relocated to Bishop's Gardens in 1963. The
wooden posts are for the market stalls. Market Place was
renamed Cathedral Square from 1964 when the covered
market moved to New Road. Originally the Market Place
was named Marketstede.

Cathedral Square

Now Cathedral Square has been redeveloped with
fountains spouting up from the ground along with
new street furniture and paving. Meanwhile, work is
progressing on the creation of a new St John's Square
in the area to the west of St John the Baptist Church,
Cathedral Square. This part of the regeneration project
includes new paving, two grassed terraces with steps and
a ramp leading down to the west door of the church. The
church is also undergoing improvement works to make it
more accessible and functional for city centre users.

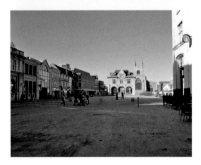

Market Place *c.* 1900

Here's a one eyed and one legged beggar resting on the lamppost in Market Place (renamed Cathedral Square in 1964). Don't forget that at this time there was no pension provision and the welfare state had not been thought of. He wears a sign to state that he was injured in the Boer War. Today the *Big Issue* sellers take up the cause for the homeless and destitute. In this picture the seller is standing next to the new form of lamppost which is actually a CCTV camera.

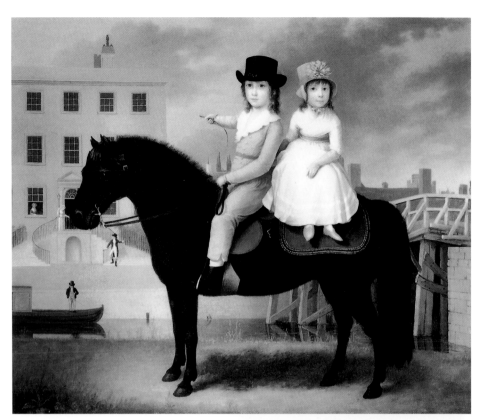

Painting of Wright Thomas Squire and his Sister Charlotte Squire in 1795
This postcard depicts a painting by Theodore Fieldings of Wright Squire, who is aged about twelve, and his sister Charlotte, aged about four.

William Squire (*d.* 1826) and his son Wright Thomas Squire were merchant bankers and founders of Squire's Bank, Peterborough during the early 1800s. William purchased Knapwell Manor (formerly property owned by Ramsey Abbey) in 1773 and it remained in the family until 1869 when the 1,043 acre estate was sold to Henry English, a Wisbech Timber merchant. A memorial to the Squire family can be found in Peterborough Parish church by John Flaxman – appointed first Professor of Sculpture at the Royal Academy of Arts in 1810.

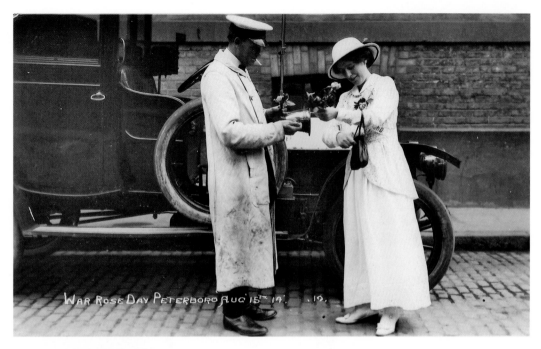

War Rose Day Peterboro Aug 15th 14.

I am thinking of You at PETERBOROUGH.

War Rose Day, 15 August 1914

On Saturday, 15 August 1914 money was being raised locally for the Prince's War Fund. The event was organised by Lady Winfrey, wife of Sir Richard Winfrey who was at this time the city's MP and Mayor. Lady Winfrey was assisted by the Mayoress, Mrs Mellows. They appealed for lady volunteers to meet at 3pm the previous day to make arrangements to sell 2,000 roses donated by florist W. & J. Brown, Narrow Bridge Street. All the volunteers initially assembled outside the council offices, of which the Guildhall was part, before going around the city to sell the roses. The idea was so successful that a total of 8,000 fresh roses were sold, raising £90. Here a taxi driver buys his rose by way of contributing to the fund.

Comic Card

A message that many British men, fighting in France and elsewhere during 1914-1918, would have sent to their sweethearts back home. These postcards were mass produced and simply overwritten with place names.

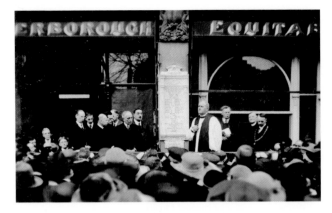

Unveiling of the Co-operative Society War Memorial, Park Road in 1919
Here is Bishop Theodore Woods unveiling the memorial tablet and the clock erected to those men employed by the Co-operative Society who lost their lives in the First World War (1914–18). The Peterborough men are: T. Askew, C. Baker, F. Bradshaw, S. Brown, H. W. Cooper, L. Cropley, A. Dale, C. Farren, S. Giblett, W. Jinks, J. Miners, O. Paul, H. Palmer, H. Sparnes, W. Sprigg, H. A. Turner, H. Waterfield, F. Whitney, R. Wilcox, C. P. Wilder, F. L. Wingrave. For March Co-operative Society the names are: H. Hall and C. R. Hudson. Whittlesey Co-operative Society: F. Lutkin. Stamford Co-operative Society: W. Bailey, C. Wakefield and C. Bartholomew. Ramsey Co-operative Society: W. Barkem and P. Mills and for Bourne Co-operative Society: H. Pridmore. (Inset) A view of the memorial clock in 1922.

Peterborough Co-operative Society Van c. 1920s
A delivery van is getting ready to be oiled and on its way to its rounds. These two men presumably having survived the Great War stand proud aside their vehicle. The Roads Act 1920 required Councils to register all vehicles at the time of licensing and to allocate a separate number to each vehicle so here is the Co-operatives van No.2 with No. 67 a furniture removals van in the background. The 1920 Act clarified the situation regarding cars driven by internal combustion engines – previously there had been a bewilderment of rules intended for road engines, horse-drawn vehicles and other traffic. The tidying up and consolidation proved eventful as it was recorded that bicycles were becoming a danger to road users!

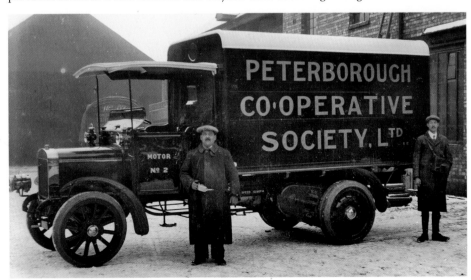

PETERBOROUGH

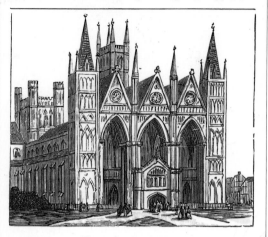

THE CATHEDRAL
Norman and Early English periods
Important Railway Centre. Bricks & Tile Works
POPULATION, 43,558.

CDV Cathedral *c.* 1890s
This cabinet print was used as a
trade card. It depicts the west front
of the Cathedral and gives a brief
description of its architecture and what
Peterborough was renowned for, along
with its population size – which at this
time was 43,668.

Cathedral; Artist's Impression *c.* 1900
You can see in the artist's impression
that Paeda, King of Mercia is inspecting
the building of the first church,
then there's a cartoon showing the
destruction of the first church and
slaughter of the monks by the Danes,
followed by King Eadgar and Dunstan
and nobles at the dedication of the
second church in Anglo Saxon times.
The existing Norman style Cathedral
is built of Barnack stone and was
begun in 1118 by Abbot Jean de Seez
and consecrated in *c.* 1238. During the
Reformation, Henry VIII preserved
the church and elevated its status
to a Cathedral in 1541. It was badly
damaged in the Civil War but fragments
of the medieval glass were preserved
and can be seen in the Apse, beyond
the Sanctuary. At the end of the
nineteenth century, the central tower
was completely rebuilt and the Bishop's
Throne and High Altar were added.
Catherine of Aragon, the first wife of
Henry VIII, is buried here, as was Mary,
Queen of Scots until her body was
exhumed and reinterred in Westminster
Abbey in 1612. Monuments to their
memory are features of the Cathedral.

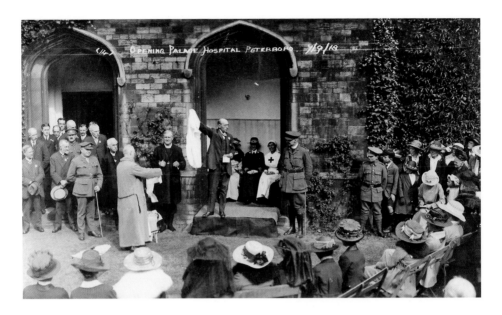

Bishop's Palace Hospital, Cathedral in 1918

With more and more wounded soldiers coming back from the front, and trains stopping at both the north and east railway stations with the severely injured, it became clear that the hospital in Priestgate (now the museum building) couldn't cope – so part of the Bishop's Palace was opened as a hospital on 7 September 1918 to provide medical care for the many wounded returning from the trenches. The First World War was to continue for another two months. Bishop Theodore Woods can be seen standing to the left of the nightgown being held up as an exhibit!

A Ward in the Palace Hospital, October 1918

Here you can see how effective the surroundings are to the soldiers who have returned from the trenches. They have clean and comfortable beds and pals visiting – not to mention the care and attention lavished on them by some very attractive nurses!

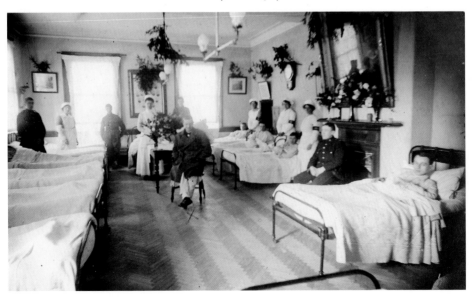

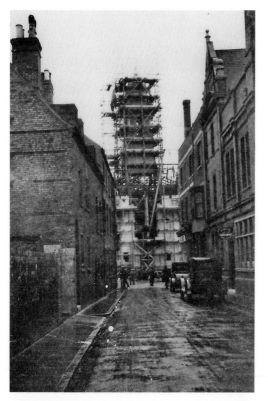

New Town Hall from Priestgate, 1933
This is a view of the construction of
the Town Hall with its copula nearing
completion. In 1929 it was decided that
the city needed a new Town Hall, as the
Guild Hall and its surrounding offices were
becoming too small for the burgeoning
growth of the city and its new boundaries.
The widening of Narrow Street was agreed
and included the demolition of all the
buildings on the east side and taking part
of the Bishop's Palace Gardens – so creating
the Bridge Street we know today.

New Town Hall
The new Town Hall was opened by
Alderman Whitsed on 16 October 1933
– the very day he was made an Honorary
Freeman of the City.

Mayoral Chair, 1895

This chair was presented to the city by Mayor John Thompson – Mayor of the City in 1881/82, 1886 and 1897. The early town was governed by the Abbots, and on the dissolution of the monasteries under Henry VIII, when the Abbey was converted into a Cathedral, certain powers were given to the Dean and Chapter. Subsequently a body known as the Feoffees became the chief civic authority, then in 1790 the Improvement Commissioners, and finally in 1874, under a charter of incorporation, the Town Council consisted of Mayor, Aldermen and Councillors. Up until 1885 the city returned two members to Parliament. Most newcomers and visitors to Peterborough are curious about the historical term "Soke of Peterborough" – but the fact is that the Anglo-Saxon word for *soc* or *soke* means "a liberty granted by the crown to a subject to administer justice or execute the territory or precincts wherein such justice is exercised". Hence the Soke or Liberty of Peterborough. The 1895 Mayoral chair now stands outside the Council Chamber on the landing where all the Mayors of Peterborough are inscribed on a stone plaque. The wood has a wonderful patina and the green leather arms and seat are intact.

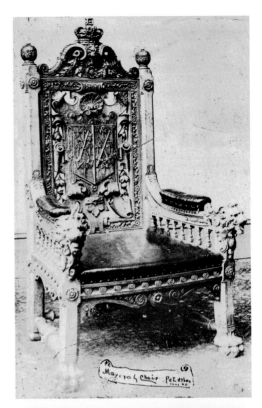

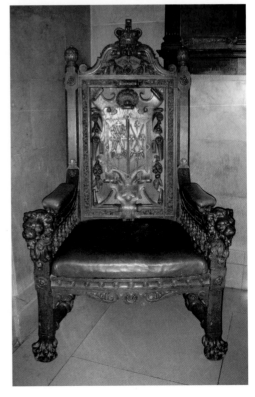

Advertisement Card, *c.* late 1950s
This postcard advertises the fact that Peterborough is to have a supplement in the *Sunday Pictorial* and that you should complete the back to secure your copy via your local newsagent. Up until 1972 the Cathedral was black with grime over the centuries before being cleaned. The supplement included the fact that Peterborough Cathedral was built between 1116 and 1238 on the site of two earlier churches, and that it was a Benedictine Abbey until 1541, when Henry VIII dissolved the Monastery and created the Diocese.

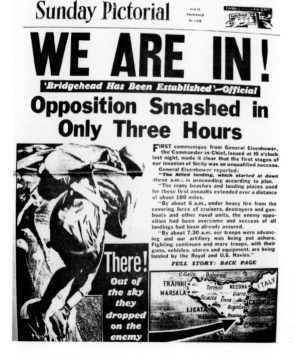

Front of *Sunday Pictorial*
The *Sunday Pictorial* began life in 1915 and changed to become the *Sunday Mirror* in 1963. Front page news in 1943 was the invasion of Sicily.

35–45 and 51, Priestgate, c. 1900

At the turn of the last century these buildings were the registered offices of the Sun Fire Insurance Company; Peterborough Corn Exchange Co. Ltd; the Clerk to the District Council; the Joint Cemetery Board; Commissioners of Oaths, Peterborough Division and more recently they were occupied by Buckle & Co. Solicitors. Today No. 45 is the offices of Regency Chambers Barristers – The Chambers of Mr Ian Martignetti. Before that part of these premises was once the Vicarage for St John the Baptist, Peterborough Parish church, Church Street. This building has gone through a massive makeover in the last 110 years. It façade has been embellished with stone work and Corinthian style columns have been added to the entrance and the wrought iron balcony has been removed but you can still see traces of the building pictured in 1900.

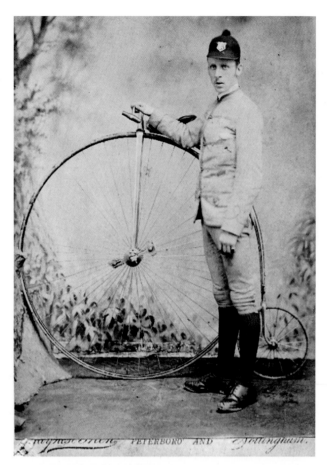

Matthew Hooke in 1884
Here we have the *carte de visite*
of a seventeen-year-old Matthew
with his penny farthing bicycle
taken by photographer, Beales
of Park Road, in 1884. Matthew
Hooke at the age of sixty-four
became Mayor of Peterborough
in 1931.

**Hooke's Shop, 12 Broad Bridge
Street, in 1909**
This is a lovely view of the
stationers and booksellers shop
he owned at the age of forty-two.
The Hooke family also had a
furniture and removal business.

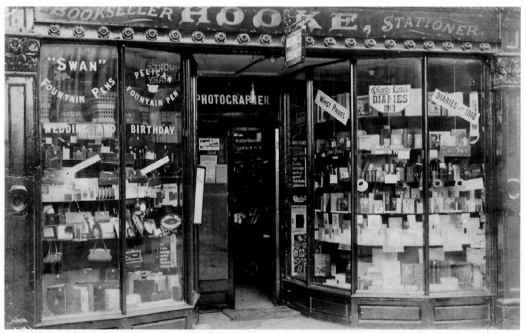

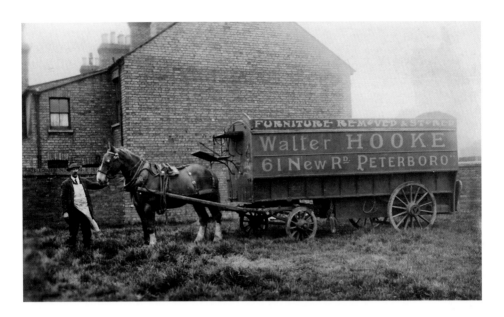

Hooke's Removals *c.* 1909 and *c.* 1927

Here is a picture of one of their horse-drawn removal vans, along with a motorised removal van. The removals company office was based at 72 Bridge Street and in this picture can be seen a team of their best men.

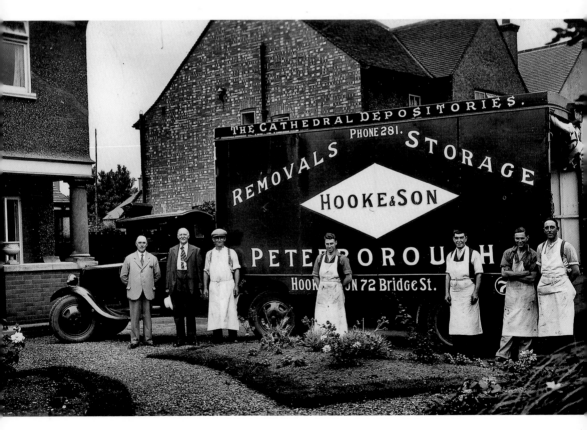

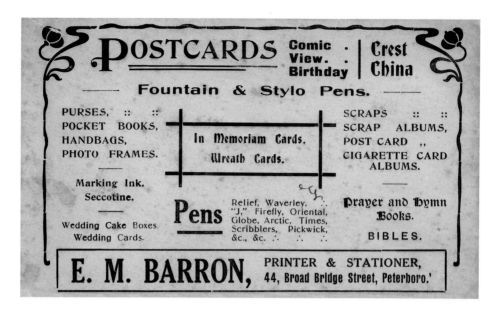

E. M. Barron, Printer & Stationer, Advertisement Card *c.* 1922
Edward Maples Barron had a shop at 44 Broad Bridge Street which sold anything from pens and stationery for every occasion to purses, handbags, photograph frames and albums. Edward lived at 60 Taverners Road. Other members of the Barron family included Ernest Harold who was a watchmaker and traded from the same premises as Edward.

G. W. Briggs Ltd, 49 Broad Bridge Street, 1924
A couple of years later George Briggs is advertising his music shop – selling pianos, musical instruments and gramophones. The advert boasts that he is the sole agent for the new Apollo player action, designed and manufactured by Melville Clark in the USA.

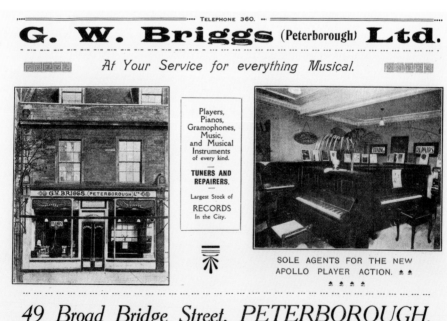

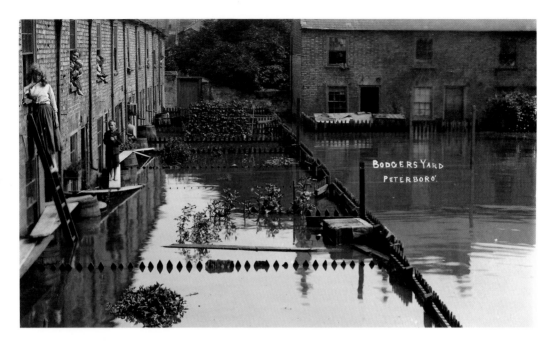

Bodgers Yard (off Bridge Street), 1912

In August 1912 Peterborough experienced widespread flooding with three weeks of heavy rainfall, concluding with 13½ hours of rain on the 26 August from 5.30am until 7pm. The following day, the River Nene near the Town Bridge rose to 17 feet 6 inches at 8pm – causing extensive flooding to areas like Bodgers Yard. Planks were quickly erected and access in and out of most houses was by ladder to the upper floor! The River Nene rose higher in 1912 than the last recorded floods of 1848 when a boat sailed down Bridge Street to the Golden Lion! Another badly affected area was School Place, off Albert Place.

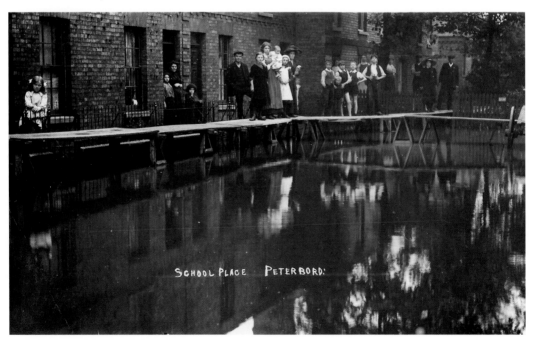

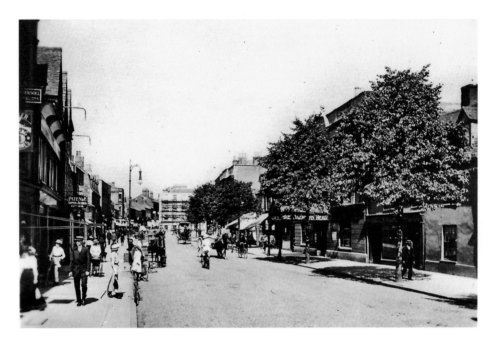

Broad Bridge Street, formerly Bradgate c. 1927

In the right foreground is House's shop then the canopy for the Saracens Head Hotel. In the left foreground is Paten's supplies and brewers, established in 1838. Scaffolding can be seen up against The Golden Lion Commercial Hotel, centre left, at the end of Broad Bridge Street. The entrance to Narrow Bridge Street is to the left of the Golden Lion. Narrow Street was widened to make way for the Town Hall building in 1933 and today there is no Broad Bridge Street or Narrow Bridge Street – simply one continuous road called Bridge Street. Today's view shows the Magistrates' Court replacing everything on the right, with Paten's supplies and brewers, now being used as a restaurant.

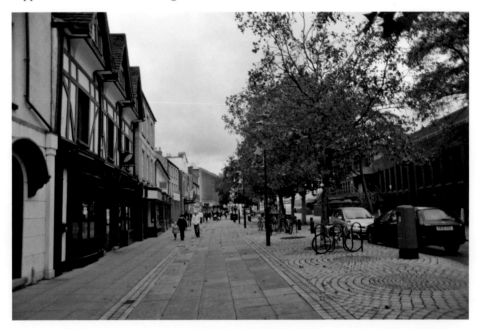

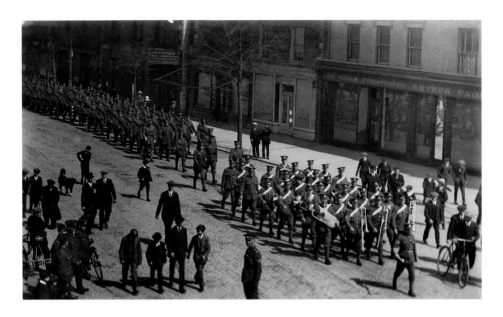

Broad Bridge Street *c.* 1917
Northants Regiment marching towards the Town Bridge with Arthur Page, House Furnishers,
in the right foreground at nos. 19 and 20 followed by a further two shops and then the sign
for S. & A. Caster, curriers, leather merchants, boot manufacturers and wholesalers. Caster's
was established in 1884 and Samuel and Arthur lived in Wentworth Villas, London Road.
The view below is taken a decade later from across the Town Bridge but you can clearly see
both sides of Broad Bridge Street and the many boats for hire on the River Nene.

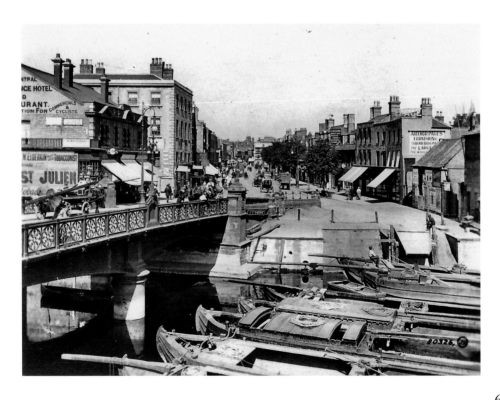

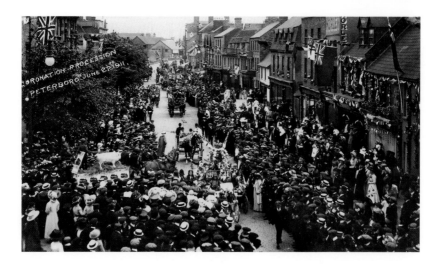

Coronation Procession, Bridge Street, 22 June 1911

Photographed from the first floor of the Golden Lion Hotel looking towards the River Bridge this postcard shows the vast crowds lining Broad Bridge Street on the occasion of the Coronation of Their Majesties King George V and Queen Mary on the 22 June 1911.

The procession of floats is making its way into the city centre – the first float is of a Coronation crown with a banner of "Long Live the King" and to the left is the float of the Pork Butchers Association; that of a replica pig standing on straw with the different cuts of pork depicted around the sides of the float.

11 Broad Bridge Street c. 1920

This is a general view of this historic house, locally referred to as the Huguenot House. The front was designed after Inigo Jones and was built in about 1748. The first occupant of this house was Monsieur De La Rue, a French refugee. Later the house was occupied by Mr Coleman & the Misses Coleman (of the company Cadge & Coleman Ltd who were later bought out by Whitworths Flour) from October 1856 to September 1920. In 1927 the premises was occupied by the Post Office (run by Miss Searle) and also the offices of The National Fuel Oil Company Ltd.

Perkins, Queen Street Workshop
c. 1934

Here is Mr Cummins standing by what could be a balanced drive wheel for a belt driven agricultural steam engine. In 1932 an entrepreneurial British engineer and a shy but brilliant engine designer set up business together in a tiny backstreet workshop in Queen Street – now under Queensgate shopping centre. Frank Perkins and Charles Chapman were two men with little money but a big idea. Perkins was enterprising, imaginative and an aggressive salesman, while Chapman was an engineering genius who dodged the spotlight. In 1959 Frank Perkins retired when the company was acquired by its largest customer, Massey-Ferguson and Frank Perkins, a Peterborian, retired from active management of the company bearing his name – which at that time employed a tenth of the city's workforce. In 1998 Caterpillar Incorporation acquired Perkins Engines. Right is the same Mr Cummins but posing in 1947 after Perkins moved its production from Queen Street to Eastfield in that year. By 1966 the company had won its first Queen's Award.

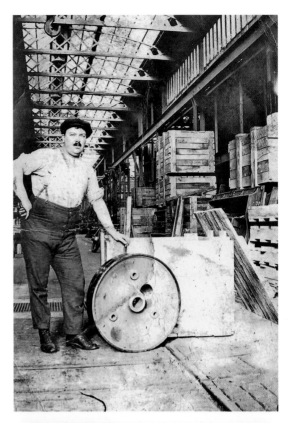

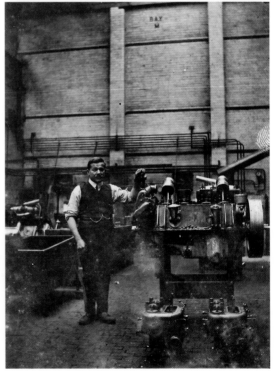

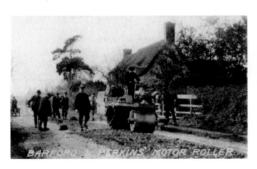

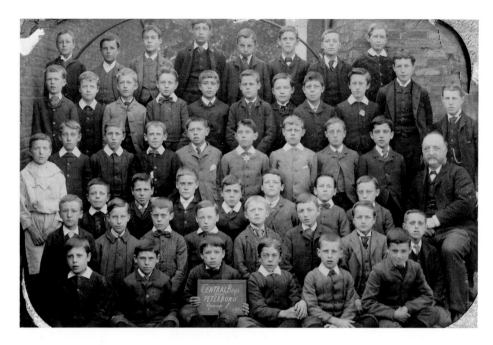

Central National School, Providential Place, off Nelson Street, *c.* 1893
This is a photograph of Group 1 class in 1893 with headmaster, Mr J. T. Dickinson, seated on the right. Miss Elizabeth Henderson was Head Mistress at this time.

Nelson Street in 1942
In contrast this is a group of police officers and wardens posing during the Second World War at their Headquarters in Nelson Street (the building of Crescent Bridge necessitated the demolition of Nelson Street).

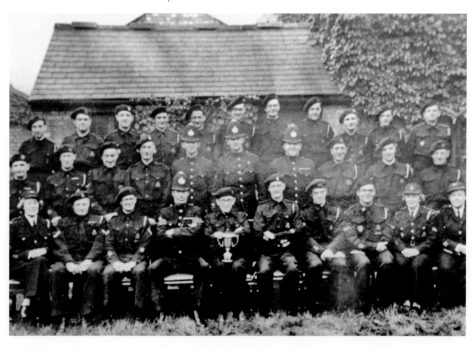

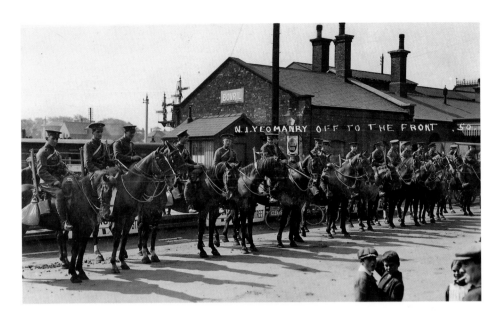

North Station c. 1915

Northamptonshire Yeomanry off to the front are parading outside the north station prior to their departure for active service in the First World War. This postcard is part of a large series, as it is number 50. There have been a number of railways stations in Peterborough: Peterborough East (1845–1966), and the existing station which opened in 1850 (previously known by various names including Peterborough North) and briefly Peterborough Crescent (1858–1866). Peterborough was the first station on the East Coast Main Line to be electrified. Peterborough as a result has the first mast to be installed as part of the electrification project. This view is approximately where the Yeomanry would have been parading and its novel to see that the horses have been replaced by bicycles.

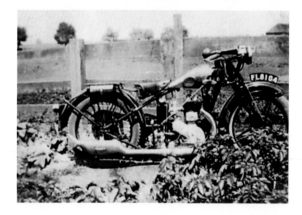

Ariel A Motorbike *c.* 1927
This is a 557cc motorbike with local registration plate FL 8104 which was manufactured by Ariel – the company that started life as a manufacturer of air inflated rubber tyres for horse-drawn carriages around 1847. One can only hope the Ariel A motorbike didn't end up in the Milton Street scrapyard of H. Sykes & Sons for spares.

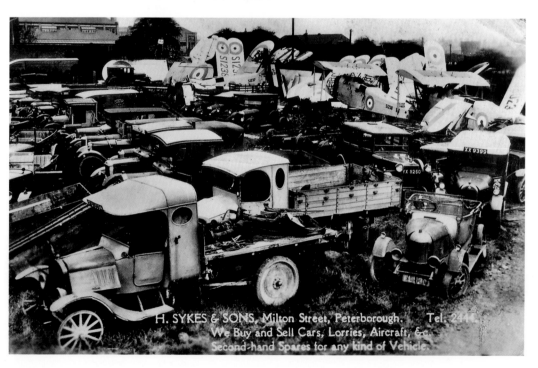

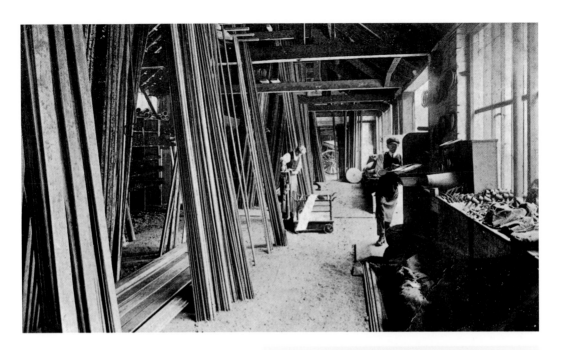

**Lawrence Brothers, Chapel Street,
c. 1907**
Lawrence Brothers were wholesale
ironmongers whose warehouse was
located at 2 Chapel Street. They sent
this postcard to Messrs Charles Cade
& Son in Ramsey to let them know
that their order would be completed
on 14 November 1907, and that they
looked forward to further orders
being placed.

J. Woodall, 13 Westgate, c. 1898
John Woodall's shop supplied
household ironmongery, including
items like bedsteads, fretwork, stoves
and lamps. They were wholesale and
retail suppliers of general furnishing
ironmongery.

GENERAL
FURNISHING IRONMONGERY
AND
ELECTRO-PLATE DEPOT.

Bedsteads and Mattresses.
BRUSHES AND MATS.

Fretwood and Appliances.
STOVES, TOOLS & LAMPS.

WHOLESALE AND RETAIL.

J. WOODALL,
13, WESTGATE,
PETERBOROUGH.

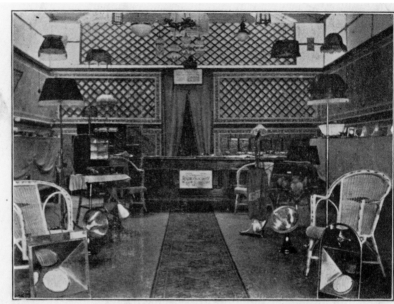

The

Northamptonshire

General

Electrical

Company,

Peterborough.

Telephone: 148.

Telegrams:

Northants. Electric.

CORNER OF MAIN SHOW ROOM.

8a Cowgate, *c.* 1929

The Northamptonshire General Electrical Company showroom sold all manner of electrical goods from radios, electric lights and electric heaters to the latest electric carpet cleaner. The showroom was opposite Queens Street. Today Queensgate shopping centre occupies most of what was Queen Street and Cumbergate. No. 8 Cowgate is today occupied by Subway sandwich bar and on the left is No. 6 an Estate Agent and on the right No. 10 is yet another Estate Agent. No. 8 a seems to have disappeared.

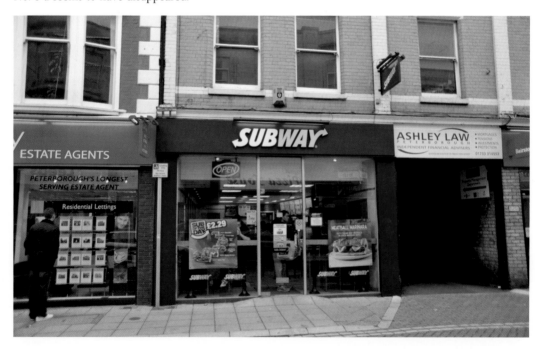

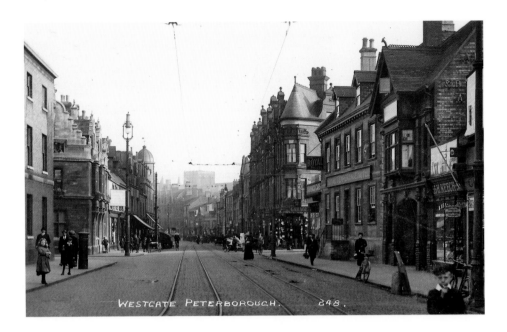

Westgate in 1914

The Royal Hotel (53 Westgate) is the second building on the right at the corner of Westgate and Queen Street. In the right foreground is Keech, the hairdressers, located at 55 Westgate. The junction on the left takes you down North Street and the building in the left foreground is presently the doctors' surgery. The tram lines in the foreground are turning towards Lincoln Road. The trams would take you out of the city to the terminus at Walton. At first glance today there appears to be little difference. However, the building on the left at the corner of North Street is the Co-operative society's store – Westgate House. On the right before and after the Royal Hotel building (now "Bar Bloc") is the Westgate end of Queensgate Shopping Centre. Queen Street on the right of the earlier picture is completely gone.

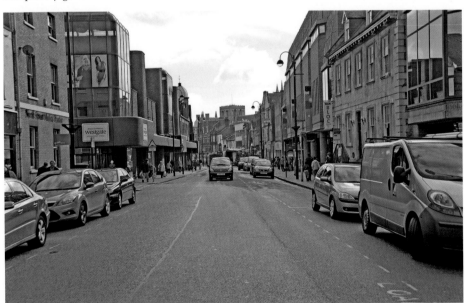

Nos 11 and 13 Westgate *c.* 1936

In the left foreground is the butchers, J. H. Dewhurst Ltd who traded from 11 Westgate and next door at 13 Westgate is the grocer's, George J. Mason Ltd. John Smith is the boy in the picture with his mother. During his retirement, in the early 1990s, John Smith became Verger of Peterborough Parish church – St John the Baptist. Today Dewhurst has been replaced by a gentleman's outfitters and further on is New Horizons, and amusement arcade. You can also see the recently refurbished entrance to Westgate Arcade.

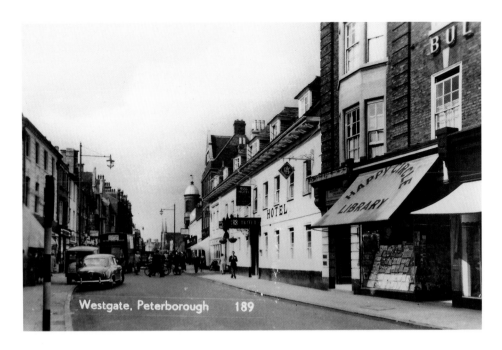

Westgate, Peterborough 189

Westgate in 1962

Here we have Ellis Bell, Tailors & Outfitters in the right foreground, followed by The Happy Circle Library which formed part of the Mansion House Buildings in Westgate. The Bull Hotel is very visible and opposite the hotel's entrance was J. H. Dewhurst Ltd, butcher's at No. 11 Westgate with J. R. Johnson & Sons Ltd, butcher's at No. 19 Westgate with the entrance to Westgate Arcade separating the two butchers' shops. The Bull Hotel continues to stand proud in Westgate. The Happy Circle Library is now Shrives, the chemists. The copper cupola of Westgate House can only just be seen, centre skyline.

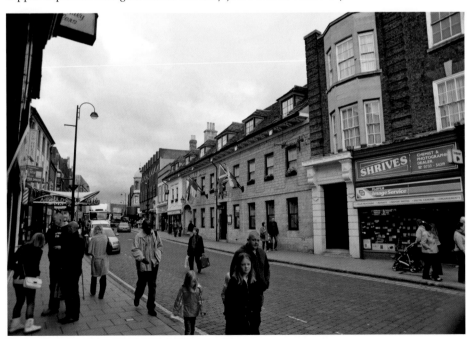

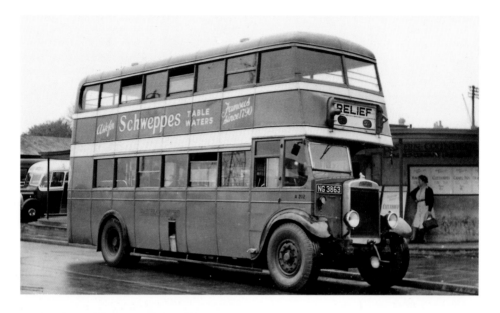

Bus Station, Bishops Road, *c.* mid 1930s

This is an Eastern Counties Leyland Titan TD2 bus with a Norfolk registration number plate and a fleet number of A202. These Leyland buses were built mainly for the UK market between 1927 and 1942, and then between 1945 and 1968. Eastern Counties was formed in 1931 by the combination of four existing bus companies in East Anglia, the earliest of which started in 1902. Eastern Counties operated throughout Cambridgeshire, Norfolk, Suffolk, and the Soke of Peterborough which in 1974 became part of Cambridgeshire. Nowadays the bus station is located within the Queensgate shopping complex which opened on 9 March 1982. Pictured is a 2008 Gemini bodied Volvo B9TL bus that runs from Peterborough to Lowestoft. It is a state of the art double decker with floor access and dedicated wheelchair space.

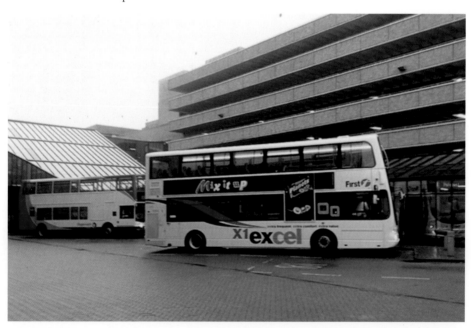

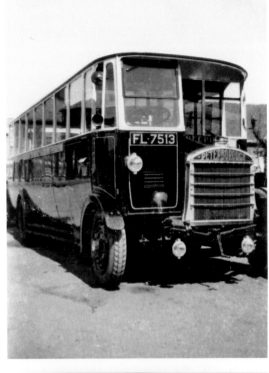

Bus belonging to Peterborough Electric Traction Co. Ltd, *c.* 1929

This is one of a batch of twelve similar buses delivered to the Peterborough Electric Traction Co. Ltd between March and May 1929. They were S.O.S. M types manufactured by the Birmingham and Midland Motor Omnibus Co. Ltd who built buses for various operators, as well as for their own fleet, as they were bus operators in their own right. These buses had Brush 34 seat front-entrance bodies although the seating capacity was reduced to 32 by the time they were taken over by Eastern Counties in July 1931. FL7513 was photographed in 1929 perhaps within a few weeks of delivery. The view below is of Mr Prentice taken in 1930 or 1931 judging that the front offside tyre looks well worn.

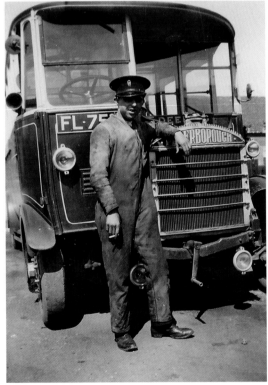

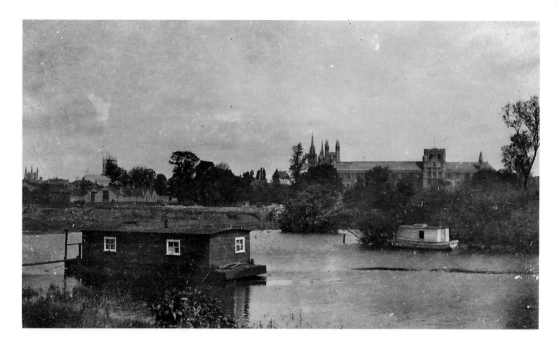

River Nene *c.* 1930s

Houseboats come in many different permutations of vessel but essentially a houseboat is a permanently moored vessel used as a dwelling which will not move from its berth other than for long term relocation. This accommodation was more reasonable to purchase than a house – and some people preferred it to living on land. Notice the Cathedral in the background so this view is taken from the south side of the river. Today houseboats and barges are just as popular. They are economic for first time buyers who want something a little special and individual.

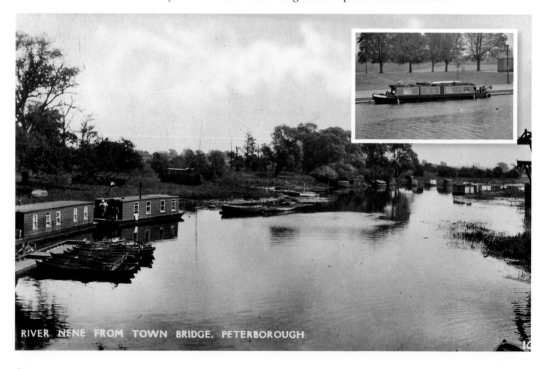

RIVER NENE FROM TOWN BRIDGE, PETERBOROUGH.

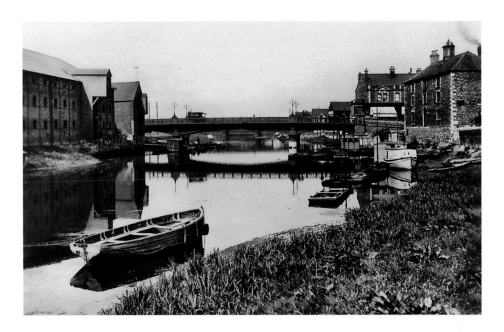

Town Bridge *c.* 1929

Looking west from the bank of the River Nene you can see the Customs House in the background on the extreme right. The Customs House dates from the early eighteenth century. Barges or Fen "lighters" used to move up and down the river with their cargoes of grain, stone, coal and malt. River traffic continued up until as late as 1910, the Customs House monitoring the flow of cargo and collection of tolls. Goods shipped along the river were held here until the appropriate tolls were paid, and they would then be shipped upstream to Northampton or downstream to Wisbech. The buildings on the left are grain stores and timber yard. The Grain Barge, floating Chinese Restaurant has been a landmark on the River Nene for many years now. Behind it is the Customs House where the sea cadets meet. Very visible on the right are the Rivergate apartments and shopping centre. Former city council planning department offices, part of Bridge House, can be seen on the left.

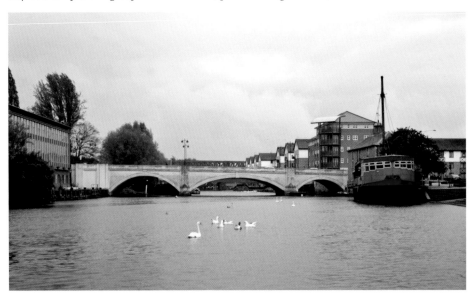

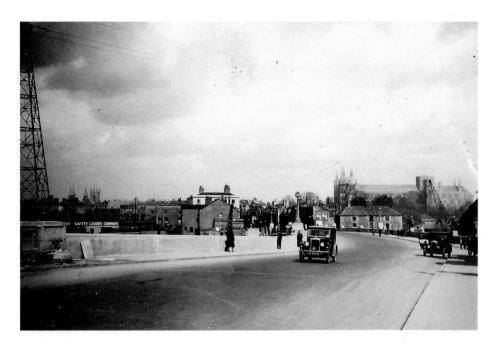

Town Bridge _c._ 1934

Looking towards Bridge Street you can see the Customs House centre right. The Cathedral is prominent in the right background and the cupola of the newly built Town Hall (completed in 1933), is only just visible in the centre background, above the rooftops. Notice that the pavement in the left foreground is still under construction. Construction of the Town Bridge began in 1931 and cost £140,000. The formal opening took place on 20 September 1934 and was performed by the Marquess of Exeter. The bridge continues to be a vital artery in the city's road transport system. A couple of years ago the road layout was changed and traffic lights installed.

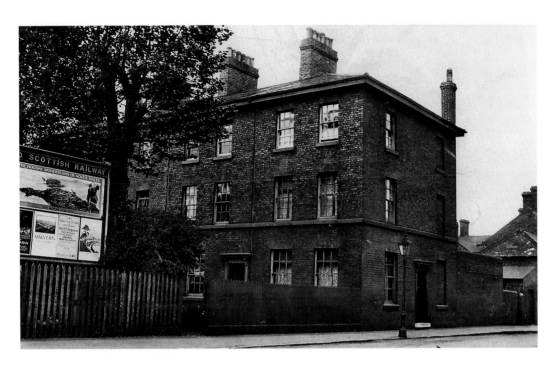

No. 1 Nene View, Station Road c. 1930s
These are the railwaymen's lodgings, later used as railway offices, situated between the Crown Hotel and the East Station, before 1939. Visible in the left foreground is a London Midland and Scottish billboard detailing trips to Colwyn Bay, Malvern, Nottingham and Cheltenham. Currently this whole area is waiting redevelopment as part of the regeneration of the south east quarter of the city. The view today is simply a car park for Aqua House.

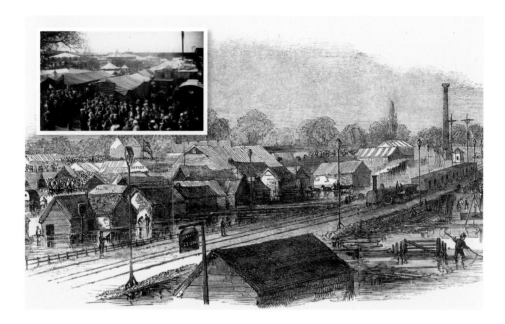

Bridge Fair in 1848, 1913 and 1928

The sketch shows the fair being held during the floods of 1848 when a boat sailed down Bridge Street. The next recorded floods that devastated the landscape came in 1912 and 1916. Fairs have always brought townsfolk and commerce together. Statute fairs like Bridge Fair, chartered in 1439 during the reign of Henry VI, were important – attracting the Mayor, Town Beadle, and senior policemen, plus enough people to warrant the notice "Beware of Pickpockets" seen centre left of the postcard showing the ceremonial opening of Bridge Fair in September 1913. The Mayor is Councillor John Barford who can be seen in his robe and chain of office, immediately behind the Beadle. Crowds flocking to the fair in search of excitement and thrills, as witnessed in the two *c.* 1928 postcards. One shows a view from Town Bridge across the Fairground with the GNR main line in the background.

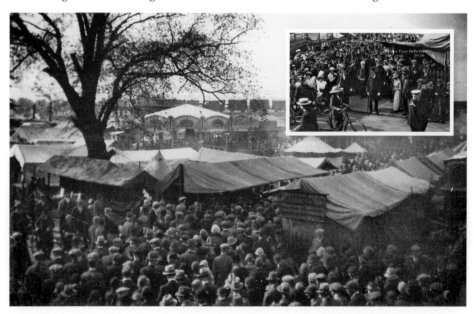

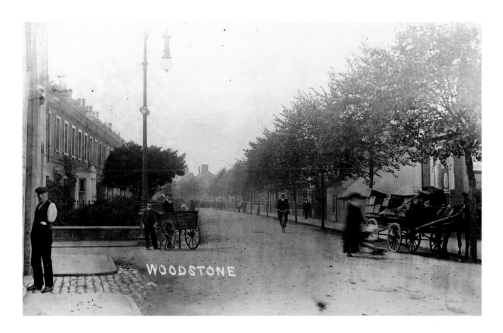

WOODSTONE

Oundle Road in 1909

Grove Street is in the immediate left foreground. The gentleman on the left is making his way through the gated passageway that used to take you through to Fletton Tower from Oundle Road. The hand cart belongs to the grocer J. W. Harrison of Bread Street and the horse and cart is stocked up with crates of Stones ginger beer being delivered to the Cherry Tree pub just out of sight in the right foreground. The later picture dates about late 1960s, early 1970s.

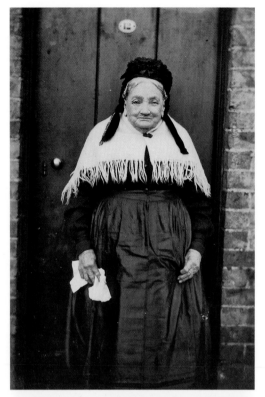

A Centenarian of Woodston in 1915
Standing proud outside 12 Tower Street,
Woodston on the occasion of her 100th
birthday is Mrs Rebecca Parrott. To think
that she was born on 30 June 1815 (the
year of the Battle of Waterloo) and reached
her 100th birthday during the turmoil
of the First World War! In her lifetime
she witnessed an era of Nationhood
and Imperialism, plus Expansion and
Insurrection. Over her 100 years she was
ruled by five monarchs: George IV, William
IV, Queen Victoria, Edward VII, and George
V. Today's occupant/s perhaps cannot boast
of such turmoil and change but it's good to
see that the house is still standing.

Woodston, _c._ 1900
This is Mr & Mrs Holland of Woodston posing
for the photographer. Look how glum he looks.

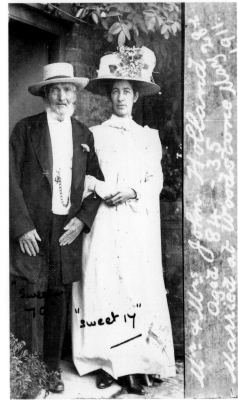

Woodston, 1911
Now look at him several years later. He's a
changed man – all smiles – but then he has
a new wife aged thirty-five and he's eighty-
four! Someone has written on the back of this
postcard "England's Last Hope" whilst on the
front "sweeter 70" and "sweet 17"! The couple
married at Woodston on 28 May 1911.

130 Palmerston Road, Woodston in 1904

Here is Mrs Elizabeth Hardiment with her daughters. The sign on the left is a notice of the sale, by Fox & Vergette of these valuable freehold cottages and a butcher's shop on Tuesday, 1 March 1904 at the Angel Hotel. The property today is still privately owned and stands out amongst the other terraced houses with its rendered and white painted front elevation.

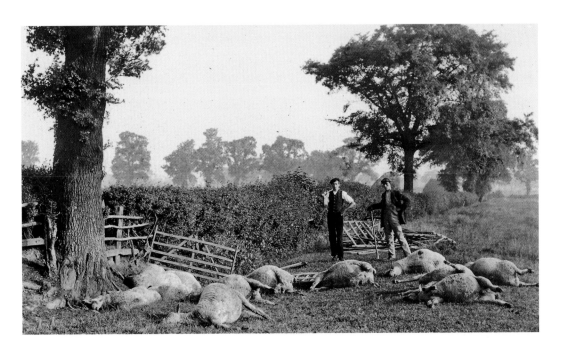

Orton Longueville 1910
A herd of sheep struck by lightning and killed on Sunday 3 July 1910. The view is of a field opposite the old British Sugar Beet factory on Oundle Road. As with most villages the majority of the fields have been built on. The bungalow to the right is on the corner of the entrance to Johnston Printers [formerly East Midlands Allied Press (EMAP)]. To the left, Oundle Road takes you to the city centre.

London Road c. 1919

The London Brick Company (LBC) was established in 1899 by John Hill who brought together the Peterborough and Fletton brickworks. At that time the Peterborough brickworks had the largest Hoffmann kiln in the world, capable of baking 1 million bricks at a time! LBC was incorporated in 1900 under the leadership of Sir Malcolm Stewart. Its activities expanded in the 1920s and demand for bricks peaked in the 1950s and 1960s due to the rebuilding of London after the Second World War. The view is of the brick works from the rear of London Road.

LBC Peterborough Bricks c. 1920s

The London brick brand goes back over 130 years. Today there are more than twenty-five different bricks on the London range – from the soft and sandy Herewood light, to the dark, distinctive wavy-ridged Rustic. Between 1968 and 1971, the LBC bought several competitors including the Marston Valley Brick Company. LBC was acquired by Hanson PLC in 1984. Production of the London Brick is now concentrated solely at Peterborough.

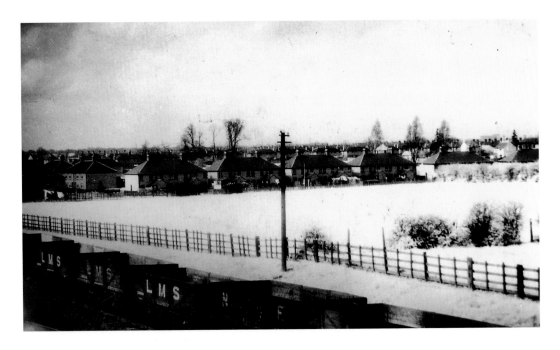

Fletton Loop *c.* 1949

This is a view from Fletton loop which is thought to have had no regular traffic after the late 1950s. The LMS wagons in the foreground would have been used to transport bricks from all the brickworks within the Peterborough area. In the centre of the picture you can see the rear gardens of houses in Celta Road. The property on the immediate left is the beginning of Belsize Avenue. The earlier picture could well have been taken from the bridge on London Road but it's difficult to say because the present day view is completely obstructed by new houses built on Prospero Close in the last twenty years.

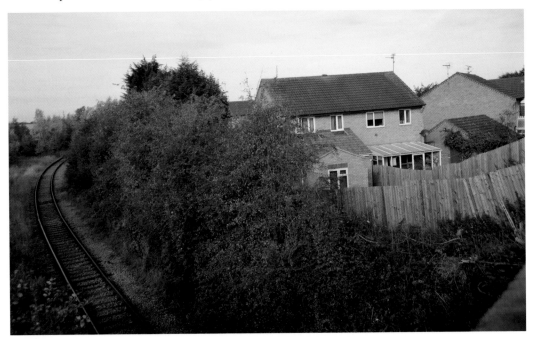

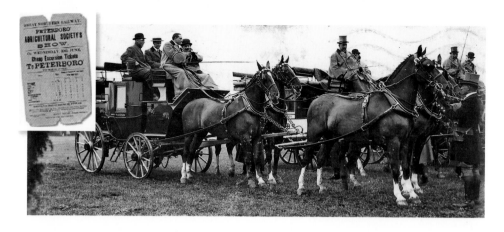

Peterborough Show, Eastfield 1913

Here's the winning coaching team at the showground at Eastfield (prior to 1911 the showground was located at Millfield). These heavy horses are associated only with draught work (drawing ploughs or pulling drays etc) in agriculture and industry. The coachmen/drivers would demonstrate their skills by the agility of racing their coach and horses around a course to win a medal within a certain class (single, double pairs or pairs-drawn coach). Peterborough Agricultural Society was formed at a meeting held at the Angel Inn, Narrow Bridge Street, under the chairmanship of William Waller on 10 January 1797. Earl Fitzwilliam was elected first President.

Display at the Peterborough Show c. 1928

A Hoover potato digger with its topper, newly patented, stating that there's no longer a need for mowing or pulling the tops of potatoes. This piece of agricultural machinery could be purchased from F. C. Smith of 93 Lincoln Road (now a private house). From the Wagon and Horses yard, the Peterborough Agricultural Show moved to Boroughbury in 1870 and in 1890 it was held on the site of the former Odeon cinema reaching from Park Road to Broadway where it remained until 1910. It then moved to a site belonging to the Peterborough Land Company, through which Broadway now runs. Another move took the Show to Millfield, on a site behind the Windmill Inn, Windmill Street and which stretched as far as Taverners Road. One firm which seems to have occupied part of this site was Quemby, the corn merchant. In 1909 when the Society was told the land would be required for building purposes (Cambridge Avenue and other streets) they looked around for another site and this time bought land in Eastfield Road (now the vicinity of Tate Close and its surrounds). A permanent grandstand was built at Eastfield in 1936, with seating for 2,000 people, at a cost of £7,000 and by 1954 the site occupied 46 acres. The Show was held at Eastfield until 1965 when it moved to the East of England Showground at Alwalton – entrance pictured below.

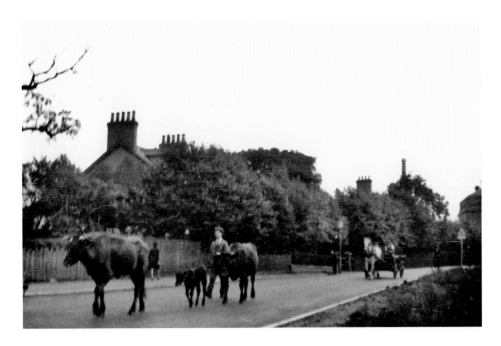

London Road *c.* 1936

A very rural view of London Road with a horse and dray on the right and cattle being driven towards town – no doubt on their way to be sold at market. This was the major trunk road into and out of the city to Yaxley and then onto London. Unusually the present view shows less of the trees and more of the houses. To the far right can be seen Phorpres House originally The Coffee Palace but now privately owned apartments.

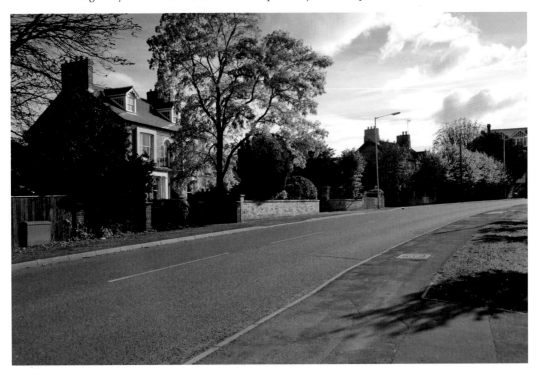

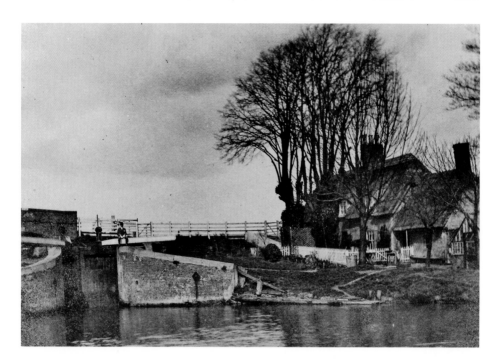

Stanground Loch, North Street *c.* 1908
The sluice house on the right was occupied by sluice keeper, Christopher Freear. At the time of this photograph Stanground was 2 miles south of Peterborough and covered an area of over 2,000 acres with a population of 1,527 (753 males) and was governed by Old Fletton Urban District Council. Stanground had an elementary mixed school in Chapel Street and a mixed infant's school in Church Street. Today a new loch is fitted and the area is well used by both residents and holiday makers. The sluice house burnt down in 1909 and a major contributing factor, unbelievably, was due to the lack of water.

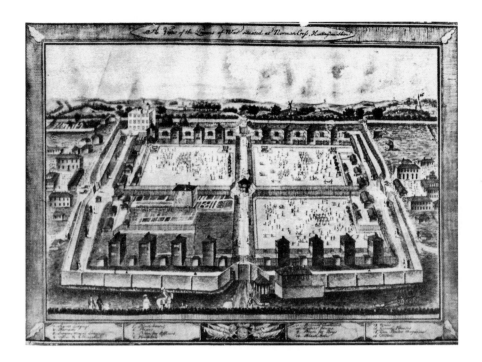

Norman Cross Napoleonic Prisoner of War Camp c. 1810

During the Napoleonic Wars a prison depot was specially constructed at Norman Cross, near Peterborough, to house up to 7,000 prisoners of war. These internees came from many of the conflicts of the period, such as the naval battles of Camperdown and Trafalgar, and the capture of enemy colonies overseas. In the period from 1797 to 1814, a total of 1,770 prisoners of all nationalities (but mostly French and Dutch) died at the depot and were buried in the area.

Unveiling of French Prisoners of War Memorial, 1914

On 28 July 1914 Peterborough Natural History, Scientific and Archaeological Society and L'Entente Cordial Society raised a memorial to the Napoleonic war dead, on the west side of the Great North Road (A1) at Normans Cross. This monument consisted of a stone column with a bronze eagle on top.

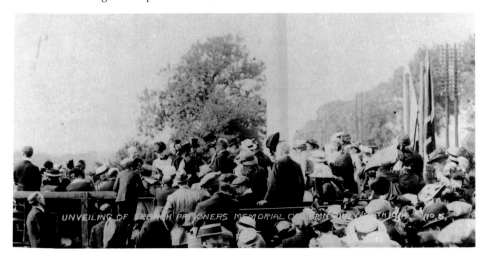

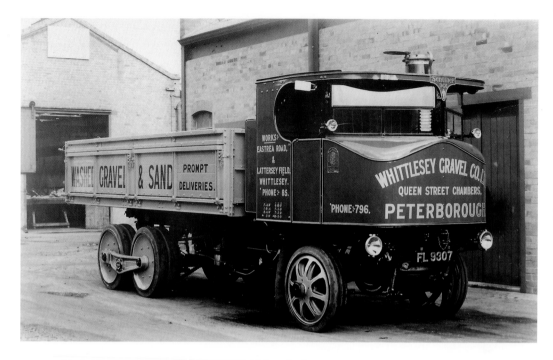

Whittlesey Gravel Co. Ltd, Lorry c. 1928
This is a Sentiner DG6 lorry used for sand and gravel deliveries. The offices of Whittlesey Gravel Co. Ltd were located in Queen Street Chambers, Peterborough with the works located in Eastrea Road, and Lattersey Field in Whittlesey.

Lorry crash at Phorpres Bridge, London Road, c. 1947
Well this work's lorry never quite made its destination. Instead it managed to crash at London Road. The London Brick Company chimney's are visible in the background. A school boy looks on whilst a trilby hated gentleman discusses events with what looks like the driver of the crashed lorry. It would appear that the contents of the lorry include road work signs and a road marking devise. Sadly the lorry looks to be a complete write-off.

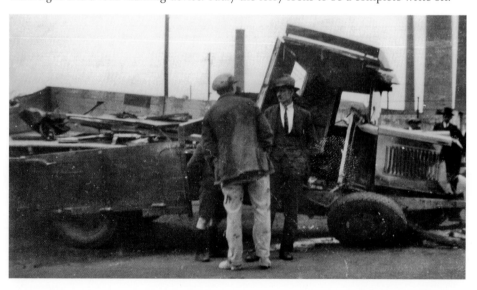